LEGENDS & LORE
of
WESTERN PENNSYLVANIA

LEGENDS & LORE
of
WESTERN
PENNSYLVANIA

THOMAS WHITE

THE
History
PRESS

Published by The History Press
Charleston, SC 29403
www.historypress.net

Cover image: Courtesy of Filmet: A Graphics Solution Company.

First published 2009
Second printing 2010
Third printing 2011
Fourth printing 2012

Manufactured in the United States

ISBN 978.1.59629.731.9

Library of Congress Cataloging-in-Publication Data

White, Thomas.
Legends and lore of western Pennsylvania / Thomas White.
p. cm.
Includes bibliographical references.
ISBN 978-1-59629-731-9
1. Folklore--Pennsylvania. 2. Legends--Pennsylvania. 3. Tales--Pennsylvania. 4.
Pennsylvania--Social life and customs--Anecdotes. 5. Pennsylvania--Biography--
Anecdotes. 6. Pennsylvania--History, Local--Anecdotes. I. Title.
GR110.P4W47 2009
398.209748--dc22
2009019603

For Mom and Dad

CONTENTS

CONTENTS

ACKNOWLEDGEMENTS

Any book on folklore, by nature, relies on the contributions of many people. That is certainly the case with this volume. On a personal level, I would like to thank my parents, Tom and Jean, for all their years of sacrifice that made everything I have done possible. I also want to thank my wife, Justina, and my children, Tommy and Marisa, for their support in finishing this project, and my brother Ed for his advice.

Doug MacGregor and Steve Doell began gathering folklore with me years ago at the Heinz History Center, and their work provided vital contributions to this book. Emily Jack put in many volunteer hours conducting interviews about urban legends, and I relied heavily on her research. The staff of the Library and Archives of the Heinz History Center, especially Bob Stakeley, Art Louderback and David Grinnell, was extremely helpful and accommodating during my research, as was Courtney Keel in the Museum Division. I also need to thank Paul Demilio, Aaron Carson, Megan Defries and Elizabeth Williams for proofreading and their constructive comments, as well as Michael Hassett for gathering information on my behalf in New Castle.

Many other people made important contributions to this book in one form or another, including Jim Matuga, Bob Bauder, Kerry Crawford, Dr. Joseph Rishel, Anne Marie Grzybek, Stephanie Busi and Bob Shema and the rest of the B-25 Recovery Group. And special thanks to Dan Simkins, Brian Hallam, Vince Grubb, Ken Whiteleather, Kurt Wilson and especially Tony Lavorgne, all of whom have accompanied me at various times while I have been out chasing legends.

INTRODUCTION

Western Pennsylvania is an area rich in folklore and legends. This region was forged by blood and steel and by innovation and faith. It has been many things—a battleground, a gateway to the frontier, a workshop for the world and a center of religion and education. Tradition thrives here. Families took root in western Pennsylvania and stayed for generations. They formed stable, tightknit communities in the cities, along the rivers and in the hinterlands. That stability allowed the population to maintain connections to the past, and regional folklore flourished. Traditional beliefs, customs and stories were handed down orally at first and later in printed forms. Legends that might have been lost in an area with a more transient population survived here.

While growing up in the suburbs of Pittsburgh, I heard many of the legends related in this book, as well as many that I have not included. Before the age of eight, I was already familiar with the Lost Bomber of the Monongahela, the ghosts of the Conneaut Hotel and others. By the time I was in high school, I had heard all about the Kecksburg incident and the cults that practiced their dark arts on Blue Mist Road. Somewhere in the back of my mind, I filed all of those entertaining and mysterious stories away for future reference. In college, I went into the field of history (public history specifically), and archives and museum work became my career. Folklore has a strange relationship with traditional academic history. Despite the fact that they are intertwined on a local level, in academia the two fields usually run parallel and rarely intersect. One place in which they do cross is in the area of public history, a field that serves as a bridge between the academic and the popular. Working in the field of public history allowed me the opportunity to gather and examine regional folklore. The result is the volume that you are reading now.

Introduction

The most difficult part of writing this book was deciding what stories to include. Over the past ten years, I have gathered hundreds of pieces of regional folklore. Whenever I thought I had covered everything, I always found more. The legends recounted in this book represent only a small sampling of that folklore. They are a mixture of some of the more prominent legends, like the Lost Bomber and Braddock's gold, and some of my personal favorites, like Blue Mist Road and Old Tom Fossit. I attempted to include stories from as many counties in western Pennsylvania as possible, but I could not cover them all. For the stories that are included, I have attempted to provide as much cultural and historic context as possible within the constraints of this book.

While they are entertaining, these legends and folk tales can tell us a great deal about the people from whom they emerge. In 1968, Richard Dorson, former director of the Folklore Institute at Indiana University, wrote, "Folklore is the culture of the people. It is the hidden submerged culture lying in the shadow of the official civilization about which historians write." Folklore and legends can convey fears, provide warnings and commemorate people and events, both good and bad. They can show what communities and average people hold as important, as well as what leaves a permanent impact on them. Western Pennsylvania's folklore has all of these attributes to varying degrees. I have attempted to strike a balance between telling the stories and a small amount of interpretation when possible. I am not sure if I have always been successful in this approach. Either way, I hope that you find these mysterious legends as entertaining as I have.

LEGENDS OF THE FRENCH AND INDIAN WAR

Founding History, Founding Myth

The French and Indian War (1754–63) was an intense and pivotal conflict in the final decades of British colonial rule in America. The British, the French and the Indians engaged in warfare all along the frontier and backcountry, struggling for control over America's interior. The fighting spread to Europe and to other colonies around the world, becoming the first real world war. After nine years of conflict in the Americas and seven in Europe, the British emerged victorious, claiming the continent of North America as their prize and securing their place as the superpower of Europe. But the war also sowed the seeds of dissent among American colonists. Their resentment of British policies after the war ultimately led to the American Revolution.

And it all started in and over western Pennsylvania.

It was in western Pennsylvania that the competing sides finally collided. None was willing to yield the nearly vacant territory that was blessed with natural resources and waterways that could access the continent's interior. The young George Washington, who was responsible for the first shots of the war, would be intimately tied to each of the major battles and campaigns that took place in the area. The experience he gained was vital in his later struggles.

The war also marks the founding of Pittsburgh and the opening of western Pennsylvania to settlement. The names, incidents and locations that were involved in the region's violent birth are all well known and memorialized—Braddock, Washington, Forbes, Fort Necessity, Fort Ligonier, Fort Pitt, Fort Duquesne and the list goes on. The French and Indian War is in many ways the region's equivalent of a "founding myth."

Founding myths traditionally recount and mythologize a dramatic origin for a place or institution, like the story of Romulus and Remus in ancient Rome. They may or may not be based on actual events, but either way they contain symbolism and a sense of destiny or importance. While it was a historical event, the French and Indian War has certainly been romanticized and occasionally mythologized to varying degrees. It has also spawned legends and bits of folklore that have been passed down through the generations. The following are just a few of those legends.

Oppaymolleah's Curse

In 1751 and 1752, Christopher Gist, a frontier scout working for the Ohio Company of Virginia, traveled to the sparsely populated region known as the Ohio Country. The Ohio Country, which included present-day western Pennsylvania, Ohio and northern West Virginia, was not yet occupied by the British colonists to the east or the French colonists to the north and west. The region's only inhabitants were members of several Indian tribes who had relocated to the area to avoid European encroachment. The tribes, collectively known as the Ohio Indians, were mostly made up of the western Delaware (Lenni-Lenape), the Shawnee and the Seneca or Mingos (one of the nations of the Iroquois Confederacy) who were nominally in control of the region. The members of the tribes were struggling to maintain autonomy from the colonial powers closing in on both sides.

Gist's mission was to survey the land for the Virginia elites (and himself) who made up the Ohio Company. Both Virginia and Pennsylvania claimed the Ohio Country, so there was certain urgency to the mission. If the tracts of land were already surveyed and divided up on paper, it would strengthen Virginia's claim. The French were also looking to occupy the area to connect their colonies in Canada and Louisiana via the Ohio River.

Gist was an experienced scout and realized that he would have to keep his surveying equipment hidden while traveling in the Ohio Country. The Indians may not have fully understood the technicalities of the European process of surveying, but they knew that when it happened, settlers soon followed. If the equipment was noticed, it might have caused serious problems or even brought physical harm to Gist. When he was questioned, he claimed that he was hunting or on a diplomatic mission to the tribes.

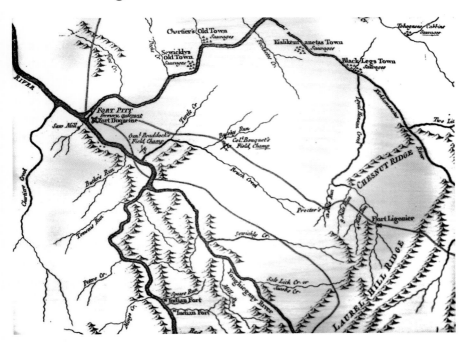

A map of the Ohio Country, now western Pennsylvania, 1770s. *Courtesy of the Library and Archives Division, Senator John Heinz Pittsburgh Regional History Center.*

One night in December 1751, Gist and his son were guests at the camp of an Indian captain named Oppaymolleah near the present-day borough of Jefferson in Greene County. Also present was another prominent English-speaking Indian named Joshua whom Gist had met before. (Joshua would later be burned on charges of sorcery.) The pair questioned Gist as to why he had travelled so far into the wilderness, and they were suspicious of his answers. Oppaymolleah, sensing Gist's real intentions, demanded to know what land would be left for the Indians if all of the land on one side of the river (the Monongahela) belonged to the British and all of the land on the other side belonged to the French. Gist had no answer. The entire encounter was recorded in Gist's journal. However, legend says that Oppaymolleah said something more that Gist did not write down. As Joshua translated, he supposedly uttered the following curse upon the land:

> *The gold will be turned to iron, and the iron turned to gold.*
> *The waters will run red with blood and the blood will turn to water.*
> *It will never know peace, only vague fear.*

If this curse was indeed put on the land, then it could be argued that at least some of it has come to pass. Money was invested into the iron and steel industries of western Pennsylvania, so in a sense the gold turned to iron. The investment made many wealthy and produced huge profits, so the iron turned to gold. It doesn't seem like much of a curse until it is remembered that many of those who were made wealthy by the iron and steel industries took their wealth out of the region.

And what of the waters running red with blood? Not long after Gist left, the French and Indian War began in the area. Bloody battles were fought near the waterways snaking through western Pennsylvania, including the defeat of General Braddock's army at the Battle of the Monongahela. The war was quickly followed by the Indian uprising known as Pontiac's Rebellion. In 1794, the Whiskey Rebellion erupted in the Monongahela Valley, only to be put down by federal soldiers. Decades later, several violent labor strikes occurred close to the rivers, such as the Railroad Strike of 1877 and the Homestead Strike of 1892.

Examples of the "vague fear" are a little harder to specify, but the region has always faced threats of one kind or another. Early settlers lived in fear of Indian raids until the 1790s. During the Civil War, the Pittsburgh area faced the threat of invasion by the Confederate army because of the munitions being manufactured in the city. The twentieth century brought new concerns. Fear of communist infiltration of the mills and unions was evident during the Red Scare and after. As a result of the Cold War, the region's industrial centers were placed on the Soviet "first strike" list in event of a nuclear war. The 1970s and 1980s saw the closing of steel mills and an economic uncertainty that still has an impact on the area.

So the question remains—is the curse authentic or just the product of a historically inspired imagination? There is no written record of the curse in colonial-era documents. It has been transmitted orally for an unknown period of time. Local folklorist George Swetnam wrote about the curse in the *Pittsburgh Press* in 1965 and later in his book *Devils, Ghosts and Witches: The Occult Folklore of the Upper Ohio Valley*. He doesn't cite a source but claims that the story was passed down in rural areas of southwestern Pennsylvania. At this point, it seems unlikely that the true origin of the curse will ever be confirmed. If Oppaymolleah did put a curse on the land, did it come to pass? You will have to decide that for yourself.

Braddock's Gold

One resilient legend emerging from the French and Indian War period is that of Braddock's gold. General Braddock's ill-fated expedition spawned many legends and stories, but none was as enticing as the idea that treasure may have been hidden somewhere in southwestern Pennsylvania. Historians and treasure hunters have spent over two centuries trying to determine the fate of the expedition's pay chest. Some believe that the French and Indians took it after the battle. Others think that members of the expedition buried the treasure while they were retreating, planning to come back for it later. Some historians, such as Edward G. Williams, question whether the pay chest was ever actually lost.

The defeat of George Washington's small force at Fort Necessity in 1754 left the French in control of present-day western Pennsylvania, then known as the Ohio Country. General Edward Braddock of the prestigious Coldstream Guard was dispatched to the colonies with a large force to protect British interests and reclaim the Ohio Country from the French. In May 1755, Braddock's expedition left Fort Cumberland and began to cut a road across the wilderness that is now Maryland and southwestern Pennsylvania. Their objective was to seize Fort Duquesne at the forks of the Ohio River (at present-day Pittsburgh). Ignoring the advice of colonists such as Benjamin Franklin, Braddock did not seek the assistance of any of the friendly Indian tribes. Braddock, a proud and arrogant man, could not see the benefit of recruiting "savages" to assist a well-disciplined expedition of British soldiers. This would prove to be a fatal mistake. By July, the expedition was rapidly approaching the forks of the Ohio. After crossing the Monongahela River, the vanguard of Braddock's army collided with a ragtag force of French and Indian soldiers on what would later be the site of U.S. Steel's J. Edgar Thompson Works.

The first shots resulted in the death of Beaujeu, the French commander, so the Indians reverted to their traditional style of wilderness warfare. They utilized the environment to their advantage, staying on the high ground and using rocks and trees for cover. The British soldiers were unable and unwilling to adapt their classical European style of warfare to the hilly, wooded terrain. As a result, they stood out in the open and were massacred. General Braddock was mortally wounded, shot while sitting atop his horse.

The surviving members of the expedition retreated back across the Monongahela and into what is now Fayette County. At Colonel Thomas

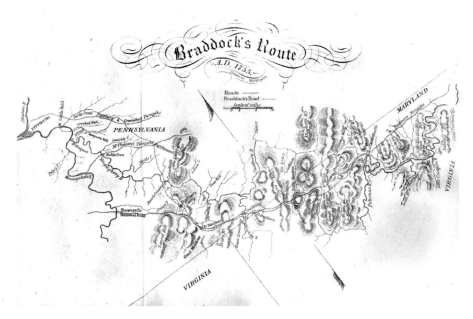

A map of General Braddock's route from Virginia to Fort Duquesne in 1755. Braddock's gold is said to be hidden somewhere along the road. *Courtesy of the University Archives and Special Collections, Duquesne University.*

Dunbar's camp, they destroyed their remaining heavy equipment so that it would not fall into the hands of the French. George Washington, who was serving as an aide to Braddock, handled the general's burial near the site of Fort Necessity. The survivors then hurried back to Fort Cumberland. The Battle of the Monongahela was one of the worst defeats the British ever suffered at the hands of the French and Indians. The chaos surrounding the defeat made the fate of the pay chest uncertain. Did it fall to the French and the Indians? Was it buried near Dunbar's camp or somewhere else along Braddock's route? Or did the pay chest ever leave Fort Cumberland?

There has been some disagreement as to whether the lost gold actually belonged to the British army or to General Braddock himself. According to firsthand accounts, there were probably at least two chests full of money taken on the expedition. One was the official pay chest used to cover the soldiers' wages and other expenses, and the other contained Braddock's personal funds. There is also a dispute over how much money was actually in the chests. James Veech wrote in 1858 in *The Monongahela of Old* that the expedition's pay chest held an estimated £25,000. He believed that the French probably captured

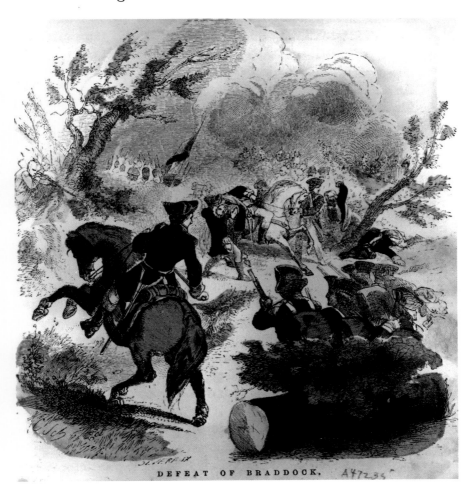

DEFEAT OF BRADDOCK.

A sketch showing the defeat of General Braddock's forces at the Battle of the Monongahela.
Courtesy of the Library and Archives Division, Senator John Heinz Pittsburgh Regional History Center.

the chest. Winthrop Sargent, in reference to Braddock's personal chest, put the figure at £10,000 in his 1856 book *History of an Expedition Against Fort Duquesne.* In the 1903 book *Braddock's Road*, Dr. Archer Hulbert agreed with Sargent's number. The *Seaman's Journal*, a source reprinted in Hulbert's book, stated that Braddock only had £1,000 in his chest. Archival sources reprinted in *Military Affairs in North America 1748–1765* (1936) indicate that the general was carrying £2,500 of his own money on the expedition. The only thing these accounts confirm is that there was no consensus on how much money the expedition had with it at the time of the battle.

A noted historian of western Pennsylvania, Edward G. Williams stated that he believed it was unlikely that a man like General Braddock, who was not very wealthy, would carry his entire fortune with him into the wilderness. It is not probable that Braddock would have had £10,000 of his own money with him. Williams questioned whether Braddock would be carrying any substantial amount of his personal money at all.

During his research, Williams discovered a letter from James Furnis, commissary of ordnance and paymaster of the Royal Artillery, which discussed the expedition's pay chest. Furnis had asked Braddock for £700 to cover certain expenses related to the mission. Braddock refused, believing that the price was too high. He then ordered that the pay chest and the wagon in which it was kept be returned to Fort Cumberland. At that point, the expedition was only one day away from the fort, and it is assumed that the wagon and its cargo returned safely.

The discovery of the Furnis letter would seem to be the hard evidence needed to solve the mystery. It certainly made clear the fate of the pay chest. Unfortunately, it does not account for Braddock's personal money. Though Williams dismisses the idea that Braddock brought along any substantial amount of his own money, most of the earlier accounts agree that he did have his own chest. Williams's analysis is probably correct, but if it is not, what happened to Braddock's gold?

It has been argued that Braddock may not have had large amounts of money with him, but as a British general, he would surely have had something. A figure like £1,000 is much more likely than £10,000. Braddock was confident that he would easily defeat the French with his large, well-trained force. His money would be safe. After the defeat, the French and Indians may have captured the chest. Firsthand accounts indicate that they did capture many of the general's personal belongings. However, none mentions a trunk full of money. One French account stated that the Indians took large numbers of gold and silver coins. It is unlikely that this was Braddock's gold. Most of the British soldiers had been paid at the fort, and they were all carrying small amounts of coins. The Indians most likely took the gold and silver off of the dead soldiers littering the battlefield. As Williams pointed out, if there had been a locked trunk or chest, the French surely would have taken it.

If Braddock did have some gold and the French and Indians didn't get it, someone must have. Proponents of the "buried treasure" version of the story believe that the retreating troops hid or buried the money somewhere along Braddock's route, portions of which remain intact and relatively

undisturbed to this day. Some local oral traditions state that the troops buried the gold after they crossed back over the Monongahela, somewhere near the site of Kennywood Amusement Park. Others believe that it was buried near Dunbar's camp when they destroyed the remaining cannons and heavy equipment. Various sites have been suggested all along the route in Pennsylvania, Maryland and even Virginia.

One version of the legend claims that Braddock actually ordered that the money be buried before they made their approach to Fort Duquesne. While camped near present-day Circleville, Westmoreland County, Braddock supposedly suggested to his troops that they hide the pay chest until after the battle. Since some of them would surely be killed, it would leave more pay for the rest, and none of the gold would fall into French or Indian hands. Braddock then went with two guides and selected a location along the Youghiogheny River, and they buried the gold under a walnut tree. Of course, since no one was able to return to reclaim it, it follows that it remains buried there to this day.

Before anyone starts to uproot walnut trees on the banks of the Youghiogheny, it is important to point out that there are numerous historical flaws in this version of the story. First, as we have already seen, the pay chest wasn't with the expedition at that point. Also, it is highly unlikely that any British general, especially the highly decorated and overconfident Braddock,

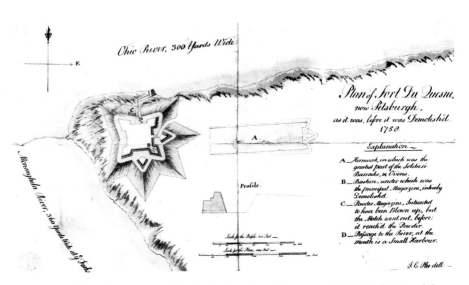

A diagram of Fort Duquesne as it looked at the time of its capture in 1758. *Courtesy of the Library and Archives Division, Senator John Heinz Pittsburgh Regional History Center.*

would feel the need to consult his soldiers to make a decision, bargain about their pay, violate military rules and then imply that they might not be successful against the small French force. From what we know of Braddock's personality, this was not the type of behavior in which he would have engaged.

Another, though unlikely, possibility is that the French, or some later treasure hunter, did acquire the gold and kept it secretly for fear of losing their prize because of regulations, laws and property rights. If that is true, then no one can find the treasure because it has already been found. The truth is that Braddock's gold probably never existed. Probably is a long way from definitely, however, and that sliver of possibility allows the mystery of Braddock's gold to live on.

Old Tom Fossit

General Edward Braddock's bloody defeat at the Battle of the Monongahela spawned a substantial amount of folklore. One popular legend deals with the circumstances surrounding the death of the general himself. Most contemporary accounts of the battle indicate that the shot that mortally wounded Braddock was fired by one of his French or Indian enemies. In the century after the battle, a different story circulated in the mountains of Fayette County. Many who lived there believed that Braddock was killed by one of his own men. The shooter was their neighbor, Thomas Fossit (also spelled Faucett and Fawcett). Fossit claimed to have been a private serving with one of the colonial militias accompanying Braddock's redcoats. Throughout his life, he repeatedly insisted that he was the one who fired the fatal shot at Braddock.

To understand why Fossit would want to shoot his commanding officer and boast about it for decades, it is necessary to understand what happened at the battle. It occurred on July 9, 1755. Braddock and his 1,460 soldiers spent almost an hour crossing the Monongahela River. They had just made it across when the forward column stumbled into a force of 900 French and Indian soldiers, who were on their way to set up an ambush. Braddock's forces were caught off guard and outnumbered at the point of contact. When the French commander fell in the first volleys, the French and Indian forces scattered and took cover behind trees, rocks and natural land formations. They occupied the high ground above the British forces. Braddock and his troops refused to adapt to wilderness settings and continued to fight in columns and platoons as they would have in Europe. The results were disastrous for the British forces. In the three-hour battle, the French and

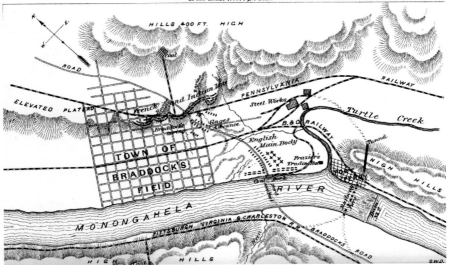

A diagram of the Battle of the Monongahela, superimposed over later development in the town of Braddock in the 1800s. *Courtesy of the Library and Archives Division, Senator John Heinz Pittsburgh Regional History Center.*

Indian forces lost about 25 men. The British lost 456 men, and 421 more were wounded. Four horses were shot from under Braddock before a shot penetrated his right arm and lung. He was taken from the battlefield during the retreat, slowly dying from his wounds. Three days later, he was dead. The young George Washington oversaw Braddock's burial near Fort Necessity.

During the battle, the militia from Virginia and Pennsylvania, who were familiar with the Indians' battle tactics, tried to hide behind trees and take defensive positions on the high ground. Braddock viewed this as cowardly and demanded that the men return to proper formation. Allegedly, Braddock used his sword to strike a man named Joe Fossit, who was using the trees for cover. At that point in the battle, many men had already fallen. Joe Fossit's brother Tom watched the general swing at his brother. That was the final straw. In the chaos of the battle, Tom took aim at Braddock and fired, delivering a fatal wound. The confusion prevented anyone from realizing what had happened, or perhaps they didn't care. As Braddock lay dying in a wagon, the British forces hurriedly retreated. Joe Fossit had survived the strike by Braddock, and sometime

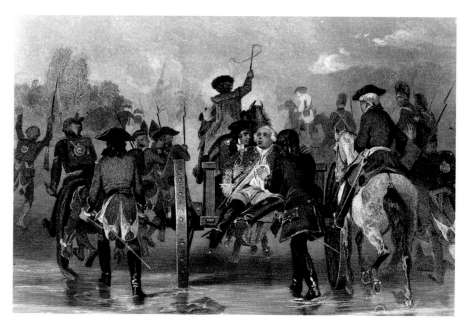

A sketch of the dying Braddock being removed from the battlefield in a wagon. *Courtesy of the Library and Archives Division, Senator John Heinz Pittsburgh Regional History Center.*

during the withdrawal he and Tom slipped away from the main British force and deserted.

The next accounts of Tom Fossit appear decades after the war. He and Joe were living in Wharton Township, Fayette County. The residents of the township and surrounding areas were all familiar with his story, and many believed it. Fossit frequently boasted about shooting the general to whoever would listen. He became very emotional when recounting the tale, especially when he had been drinking (which was often). His tears were not said to be those of remorse; rather, they were for his friends and fellow soldiers who died needlessly in the massacre. For some time, Fossit ran a tavern near Washington Springs, which served as a forum to recount his story. Sometimes when he was in a more reflective mood, he would be reluctant to talk about the whole affair. In 1788, the tavern was sold, along with the one hundred acres on which it rested. Fossit spent the rest of his days living in relative isolation in a cabin in the mountains of Wharton Township. Sherman Day wrote of Fossit in his *Historical Collections of Pennsylvania* (1843):

Legends of the French and Indian War

He was a man of gigantic frame, of uncivilized half-savage propensities, and spent most of his life among the mountains as a hermit, living on the game he killed. He would come to Uniontown and get drunk. He would repel inquiries as to the death of Braddock by putting his fingers to his lips, by tears, and by unintelligible mutterings.

Other sources have described Fossit as illiterate and ill mannered. There are so many different spellings for his name because he himself could not spell. A later writer, who never met Fossit, characterized him as a "whiskey-soaked, sinful, senile old mountain bum." The local schoolchildren were said to be afraid of him. While in most cases it would be difficult to believe the testimony of a drunken army deserter, Fossit's unpredictability and rough image actually lent credence to his claims in the eyes of his neighbors. They fully believed that he was capable of shooting the general. Fossit continued to tell his story until his death in 1822 at the unverified age of 109.

Ultimately, there is no proof that Fossit shot Braddock as he said. Then again, there is no proof that he did not. Was Fossit just a crazy old man who fabricated the story for notoriety? No one knows who actually shot

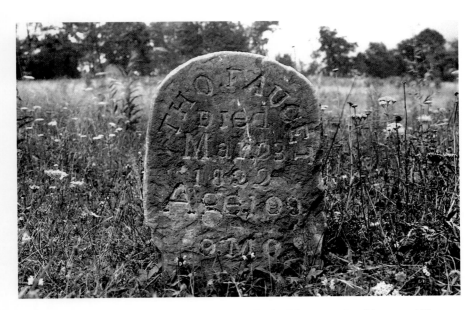

A 1932 photo of the 1822 grave of Tom Faucet (Fossit). The stone gives his age as 109.
Courtesy of the Library and Archives Division, Senator John Heinz Pittsburgh Regional History Center.

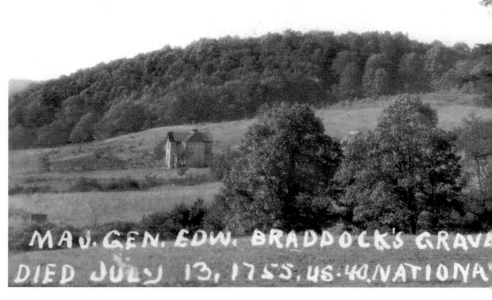

General Braddock's grave marker in Fayette County in the early twentieth century. *Courtesy of the Library and Archives Division, Senator John Heinz Pittsburgh Regional History Center.*

MONUMENT.
...HWAY. NEAR UNIONTOWN. PA.

Braddock on that chaotic day in 1755. The British were taking fire from several different directions, and the soldiers were busy trying to stay alive. The bullet could have come from anywhere. Anyone who may have known the truth is long dead.

There is one final thing to consider. Fossit may have had a piece of information that only someone who was there at the battle would have known. In 1804, when workers were transforming parts of the old Braddock route into the National Pike, Fossit is said to have correctly identified the exact spot of Braddock's grave. During the hasty retreat, his body had been buried in the road so that the marks of wagons and horses would hide the grave from the French and Indians. In the half century following the battle, no one had been able to find the grave, not even George Washington. No one, that is, except old Tom Fossit.

Bulletproof George

George Washington's early career was intimately tied to western Pennsylvania and the beginning of the French and Indian War. When the French began building forts in northwestern Pennsylvania in 1753, the twenty-one-year-old Washington was sent by the governor of Virginia to tell the French to leave. He and guide Christopher Gist made the difficult journey to Fort LeBeouf only to learn that the French would not withdraw. When the French proceeded to establish Fort Duquesne at the forks of the Ohio River, Washington was already on his way back with a small force of British and colonial soldiers. With the assistance of his Indian ally the Half-King, Washington ambushed a group of French soldiers led by Joseph Coulon de Villiers, sieur de Jumonville. Washington won his first victory, but Jumonville was killed in the skirmish. Whether he realized it or not, the war had begun.

Washington returned to the area he called Great Meadows (in Fayette County) and hastily built Fort Necessity, anticipating French retaliation. In a month, the French and their Indian allies seized the tiny fort, and Washington was handed his first defeat on July 4, 1754. Washington and his troops were allowed to leave, but he came back the following year as an aide to General Braddock. Washington participated in the Battle of the Monongahela and was one of the few uninjured officers when the conflict was over. He returned again in 1758 with General Forbes's campaign, which finally took control of Fort Duquesne and the

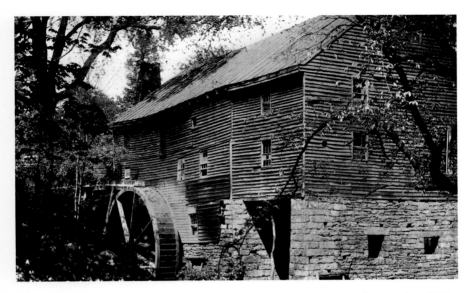

George Washington's gristmill on his property near Perryopolis, Fayette County, circa 1910. *Courtesy of the Library and Archives Division, Senator John Heinz Pittsburgh Regional History Center.*

forks of the Ohio. After the war, Washington even purchased land in both Washington and Fayette Counties and operated a gristmill near Perryopolis. He came back to the area a final time in 1794 as president to oversee the suppression of the Whiskey Rebellion.

The most amazing thing about Washington's time in western Pennsylvania is that he survived at all. Time and time again, he came within inches or seconds of death and walked away unscathed. After a while, both Washington and some of his enemies began to wonder if he was being protected by a higher power.

Washington's first close calls were on his return trip from Fort LeBeouf in 1753. After finishing the unsuccessful negotiations with the French, Washington and Gist were traveling back to the forks of the Ohio on foot, led by an Indian guide. It was December. The waterways were frozen and dangerous, and Washington did not want to risk traveling on them. After journeying for a while, they reached a snow-covered clearing. Their Indian guide ran about fifteen feet ahead, turned around and fired. After they realized they had not been hit, Gist and Washington subdued their attacker. Gist wanted to kill the Indian, but Washington would not, so they sent him off in the opposite direction. Washington and Gist then split up and met back at the Allegheny River.

When the pair arrived at the river, they realized that it wasn't completely frozen and they could not walk the whole way across. They quickly constructed a raft and made the attempt to navigate through the ice floes. They did not make it very far before they became stuck. As Washington tried to push the ice away with a pole, he was knocked into ten feet of freezing water. He managed to grab one of the logs of the raft and pull himself back on. They made it to an island—usually said to have been what is now Washington's Landing, but possibly Wainwright's Island— and spent the night. Even after his submersion, it was Gist who got frostbite, not Washington. In the morning, the river had frozen solid, and they were able to walk the rest of the way across. Washington's journal of the trip was published as propaganda against the French, and despite his diplomatic failure, he gained respect for surviving the difficult journey back to Virginia.

Washington faced death again the following year at Fort Necessity. The French and their Indian allies surrounded the poorly located fort and pounded Washington's small force for an entire day. The French probably could have eliminated his entire force if they had continued, but instead they offered to parlay. The leader of the French forces was Jumonville's brother, but rather than seeking vengeance, he offered very good terms of surrender. The French allowed Washington and his force to leave with their weapons and their colors flying. The only requirement was that Washington sign a document written in French admitting to the *assassination* of Jumonville. Washington didn't really understand what he had signed, and the British didn't care. The war was about to intensify, and Washington would soon return with General Braddock's forces.

The Battle of the Monongahela was a disaster for the British. Two-thirds of the forward column was killed or wounded, as were most of the officers, including Braddock. Washington would have made an easy target as a tall man mounted on top of a horse. In addition, he had been extremely ill in the weeks leading up to the battle and was barely able to stay upright. But again, he seemed to miraculously escape harm. During the battle, Washington had two horses shot from underneath him. In a letter sent home to his mother a few days later, he commented that he had *four* bullet holes through his coat. He wrote, "By the all-powerful dispensations of Providence I have been protected."

Another interesting tale about the battle was popularized by Parson Weems in his book *A History of the Life and Death, Virtues and Exploits of General George Washington.* According to Weems's account, when Washington was

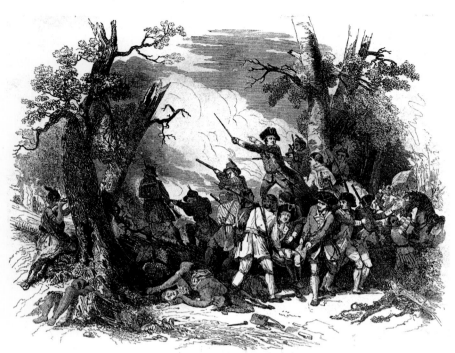

DEFEAT OF GENERAL BRADDOCK—9th July, 1755.

A sketch depicting the chaos at the Battle of the Monongahela. *Courtesy of the Library and Archives Division, Senator John Heinz Pittsburgh Regional History Center.*

visiting his property in the Ohio Country fifteen years after the battle, he met an old Indian chief who recognized him. The chief had been at the Battle of the Monongahela and had personally targeted Washington. After he missed several times, he had his warriors take shots at Washington as well. After seventeen shots, they stopped firing at Washington. The chief decided that he was being protected by the Great Spirit and could not be killed in battle. Weems is known for creating much of the Washington mythology, such as the cherry tree story, so the veracity of his account is suspect.

Nevertheless, Washington's near-death experiences did not prevent him from coming back to the region with General Forbes and his army in 1758. While the French would ultimately abandon Fort Duquesne to the British, many skirmishes were fought as the army advanced. During one of the skirmishes, a unit of the Virginia militia came under fire. Washington's unit moved ahead to support its fellow Virginians. It was almost dark, and as the units approached each other in the woods, each mistook the other for the

enemy and opened fire. As soon as Washington realized what was happening, he mounted his horse and rode between the lines, knocking down muskets with his sword and shouting for the men to stop. When the bullets ceased, fourteen men were dead and twenty-six were wounded. But Washington, who rode right in front of the firing muskets on both sides, emerged without a scratch.

The experience Washington gained in western Pennsylvania during the French and Indian War proved vital during the American Revolution. His exploits also made him one of the most respected military figures in the colonies. Despite strategic blunders, terrible conditions and intense combat, Washington endured. Was he divinely protected? Was he just lucky? No matter what you believe, it appears that George Washington really was a man who could not be killed in battle.

FROM OUT OF THE SKY COMES—CONSPIRACY?

It's a Conspiracy!

The stories recounted in this section have two things in common—they all involve flying objects that ultimately drop out of the sky and they all contain elements of conspiracy. While the falling part is easily explained by gravity, conspiracy theories are rarely as straightforward. The belief in conspiracies is as old as civilization itself. Even though they have existed in the United States since the very beginning, the modern age of conspiracy theories emerged in the 1960s and 1970s. Political assassinations, Watergate, CIA misdeeds exposed by congressional hearings and many other scandals that received increased media coverage added to public distrust of government. In the intervening decades, conspiracies seem to have popped up everywhere and touch on almost every facet of life. From the "New World Order" and UFOs to the *Da Vinci Code* and black helicopters, your average American is bombarded with images of conspiracy in books, on television and on the Internet.

Conspiracy theories thrive for many reasons. Sometimes they are supported by experts, as in the case of the Kennedy assassination. Other times, people believe because it makes them feel like part of a select group that knows what is "really" going on. The theories can provide an explanation (and someone to blame) for tragedies or the uncertainty of everyday life. Some believe in them because other conspiracies, like the Tuskegee Syphilis Experiment for example, turned out to be true. Conspiracy theories can never be completely disproved because of circular reasoning. Lack of evidence only indicates that the conspirators have successfully covered it up.

The conspiracy theories discussed here all involve accusations of coverup by the government or a government-sponsored institution (the Smithsonian).

The events in these stories all happened before the Kennedy assassination and were initially believed to be conspiracies by a small number of people. The more elaborate theories around them only became widespread in the 1970s or later. By that time, popular paranoia was flourishing, and the events received a more thorough look.

Of course, just because you are paranoid, it doesn't mean they're not after you.

The Lost Bomber of the Monongahela

Anyone who has been in western Pennsylvania for a while has probably heard some version of this story. During the 1950s, a B-25 bomber mysteriously crashed into the cold waters of the Monongahela River. The aircraft sank in minutes, and it was never seen again. Eyewitnesses soon came forward, claiming a secret government coverup. They claimed that they saw the plane removed under the cover of darkness and its secret cargo taken away. No one knows for sure what was onboard, and the government denies that any recovery was made.

The story of the "Lost Bomber" is the region's most popular conspiracy theory. The incident has led to years of speculation and the development of theories that range from the mundane to the bizarre. Some researchers continue to search the river, believing that the plane, or what remains of it, lies somewhere on the bottom. Others believe that a search is futile because the plane and its cargo, identified as anything from chemical weapons to Howard Hughes, were taken away. One thing is certain—no definitive physical evidence of the fate of the plane has ever been found.

The B-25 went down on the cold and otherwise uneventful day of January 31, 1956. According to the official Air Force report, much of which is blacked out and classified, Flight B-25N, no. 44-29125, took off from Nellis Air Force Base, Nevada, at 6:15 p.m. eastern standard time on January 30, 1956. The official purpose of the flight was to retrieve aircraft parts at Olmsted Air Force Base near Harrisburg, Pennsylvania. From there, it was to proceed to Andrews Air Force Base in Maryland, where two passengers were to be dropped off. There were to be two refueling stops along the way, one in Oklahoma and the other in Michigan. The bomber never completed its journey.

From Out of the Sky Comes—Conspiracy?

The crew of the B-25 was experienced. The pilots, Major William Dotson and Captain John Jamieson, had logged almost six thousand hours of combined flight time. The flight also had two other pilots onboard as passengers. They were Captain Jean Ingraham and Captain Steve Tabak. The remaining passengers on the plane were Staff Sergeant Walter Soocey, Airman Second Class Charles Smith and Master Sergeant Alfred Alleman.

Due to bad weather in Michigan and problems with the plane's brakes, the crewmen stayed overnight in Oklahoma. The next day, they departed for Selfridge Air Force Base in Michigan. At Selfridge, the crew faced a three-hour delay for refueling. According to the report, the crew estimated that its fuel supply was sufficient to reach Olmsted. To save time, the plane took off again at 2:43 p.m. eastern standard time without refueling. It is not clear who made the final decision to go. Major Dotson sat in the pilot's chair. Captain Tabak stayed behind.

As the flight approached the Butler Radio Beacon, seventeen nautical miles north of Pittsburgh, Pennsylvania, it began to experience difficulties. The exact nature of these difficulties is unclear because they are blacked out in the official report. What is clear, however, is that by the time the plane reached the New Alexandria Beacon, thirty-one nautical miles east of Pittsburgh, there was a significant drop in fuel in all of the tanks. With only 120 gallons of fuel left and the possibility of a leak or malfunction, the crew radioed Greater Pittsburgh Airport at approximately 4:00 p.m. and requested permission to land. It was granted, and the plane turned around and headed back toward Pittsburgh. As the B-25 approached the city, the fuel gauges indicated that the wing tanks were empty and that the main tank only contained 80 gallons of fuel. The B-25 dropped to three thousand feet, and Major Dotson altered the course to avoid heavily populated areas. It was decided to attempt to land at the closer Allegheny County Airport. The unexplained fuel loss continued at a rapid rate. At 4:09 p.m., just as the plane caught sight of the Monongahela River, both engines sputtered to a halt.

The tower at Allegheny County Airport immediately picked up the Mayday sent out by the copilot, Jamieson. At that point, it was clear that if any of them were going to survive, they had to ditch the plane in the icy cold waters of the Monongahela. Major Dotson lowered the wing flaps and successfully glided the plane into the water, just beyond the Homestead High Level Bridge. The B-25's speed at impact was about eighty knots. The time of the splashdown was about 4:11 p.m. The plane was in the middle of the river, about five hundred feet from both banks, and its nose was facing downstream. Dotson and the crew managed to escape the interior

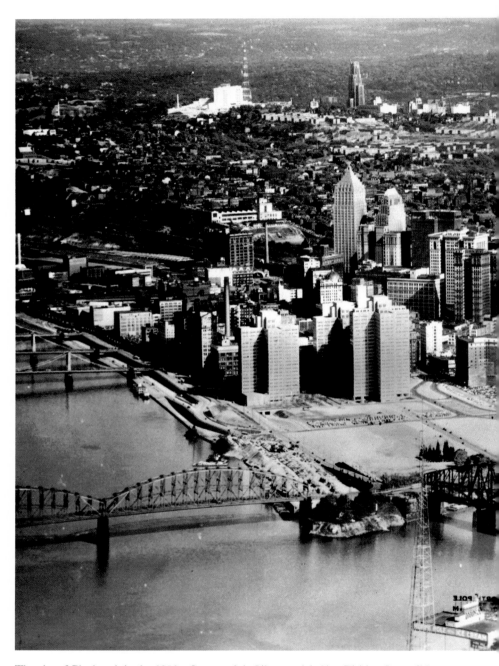

The city of Pittsburgh in the 1950s. *Courtesy of the Library and Archives Division, Senator John Heinz Pittsburgh Regional History Center.*

From Out of the Sky Comes—Conspiracy?

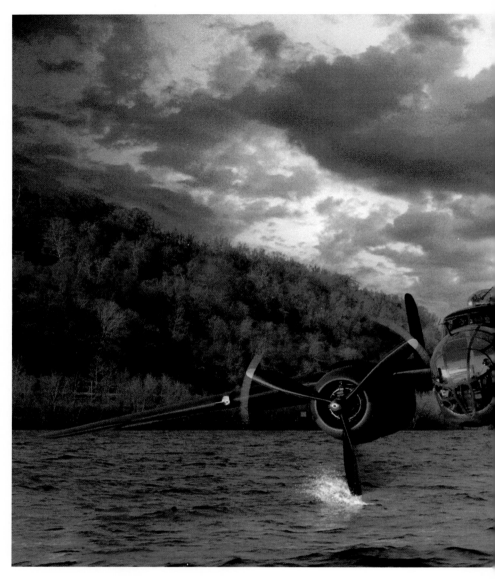

A recreation of the Lost Bomber coming in to land on the Monongahela River. After it submerged, the plane was never seen again. *Courtesy of Filmet: A Graphics Solution Company.*

From Out of the Sky Comes—Conspiracy?

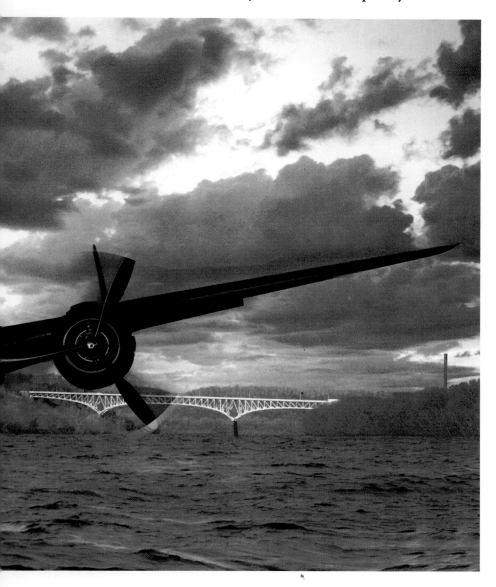

of the plane without injuries and climb onto the top of the aircraft. The official report states that both the wind velocity and the river current were moving at eight to ten knots. The temperature of the river was thirty-five degrees Fahrenheit, and the outside temperature was twenty-seven degrees Fahrenheit. After ten minutes of taking on water, the plane disappeared below the river's surface, never to be seen again.

The crew was aware that the plane was sinking rapidly and decided to swim to shore. Dotson, Alleman and Smith managed to swim to a log that was floating in the river. Dotson and Smith remained on the log and waited to be rescued, but Alleman struck out for the left bank of the river. After an exhausting swim, some bystanders and a Baldwin police officer helped him out of the water. Dotson and Smith were picked up about fifteen minutes later by a commercial riverboat. Jamieson had managed to grab onto a piece of wood that was floating down the river, and he was picked up by a police launch. Both Ingraham and Soocey disappeared while attempting to swim to shore. Their bodies were recovered several months later. The Air Force report estimates that the plane drifted for about one mile before it completely submerged near Beck's Run. It also states that Dotson and Smith, the last two crew members rescued from the river, were recovered one and a half to two miles downstream from the point of impact.

Major Dotson and Captain Jamieson were both taken to Montefiore Hospital in a state of shock. Airman Smith was taken to Magee Hospital, and Sergeant Alleman was taken to Saint Joseph's Hospital. Some initial confusion resulted among rescue personnel because Alleman's name did not appear in the flight manifest, although it had appeared on earlier ones. It is unusual for experienced Air Force pilots to make such an error. Also, another unidentified man was also taken to South Side Hospital. Some believe that he was a rescuer who went in the water to help Alleman. Others are not so sure—they believe that he may have been a mysterious seventh passenger. According to interviews conducted by the late conspiracy researcher Robert Johns, the nurses and doctors working with the B-25's crew received unusual phone calls from Nellis Air Force Base and the Pentagon ordering them not to talk to the press about their patients.

The recovery operation began on February 1, and a search headquarters was established at the AMOCO storage area along the river. The search crew consisted of local officials and teams from the Coast Guard and the Army Corps of Engineers. Dragging operations began immediately under the direction of Lieutenant Kilkeary, the officer in charge of the River

From Out of the Sky Comes—Conspiracy?

Patrol for the Pittsburgh Police Department. A river patrol launch and one skiff continued dragging throughout the morning. In the afternoon, other crews under the direction of a Mr. Whitehead of the Army Corps of Engineers joined the search. Several objects were located underwater and were marked with buoys. One object in particular was thought to be the downed craft, so the Coast Guard cutter *Forsythia* was dispatched to mark it with a lighted buoy. The next day, Mr. Harrington from the Army Corps of Engineers made a formal request to utilize the corps' equipment in locating the plane. J&L Steel Company also volunteered the vessel *Aliquippa* to assist with the search. In the afternoon, the *Forsythia* arrived and began dragging with a 350-pound anchor and two-inch manila tow rope. At 6:00 p.m., it struck what was thought to be the wing of the plane. When crewmen attempted to raise the object, the anchor slipped off and they were unable to snare it again.

On February 3, dragging operations were suspended pending the manufacture of a special "grappling hook," which was being made by the Coraopolis Tool and Machine Company. About 100 feet of five-eighths-inch cable was borrowed from the Army Ordinance Field Maintenance Section on Neville Island. The Army Corps of Engineers arranged to have the dredging barge *Monello II* moved in to assist with the recovery effort. On February 4, the *Monello II* arrived and began making 150-foot sweeps of the river with its crane and bucket. A search of the area where they believed the plane had settled turned up nothing. The *Forsythia* also continued to comb the river with the special "grappling hook." The operation continued until 7:30 p.m. that day, when thick fog forced the searchers to suspend work. The next day, dragging operations started at 8:00 a.m. The *Monello II* continued to make sweeps every 20 feet as it moved down the river. This tedious process was taking too much time, and the search barges were re-rigged in order to drag a 150-foot, four-inch steel cable. The new technique allowed them to cover an area extending from the spot where the plane submerged to approximately two miles downstream in only four hours. However, these efforts proved fruitless, and only a sunken wooden barge and two telephone poles were discovered.

On February 8, a new approach was taken. In addition to the usual dragging operations, an H21 helicopter was brought in to make flyovers of the crash site. After forty-five minutes in the air and several low passes, the helicopter left the scene without success. By the tenth, Pittsburgh police ended its participation in the search for the plane. The dragging operation

[REDACTED] At this time wing tanks were indicating empty; main tanks were indicating approximately 80 gallons total fuel remaining. A large deflection on the radio compass indicator was noted, and close proximity to River Beacon was assumed and reported to Pittsburgh Center. The aircraft was descended beneath the broken ceiling to approximately 3000' indicated. (In this vicinity average terrain level is 1100 to 1200 feet.) Shortly after descending to VFR conditions, the heavily populated fringes of the city of Pittsburgh were sighted and course was altered to a generally southerly direction to avoid housing areas. At this time it became evident that fuel was decreasing constantly at an abnormal rate and it was decided to attempt landing at Allegheny County Airport, approximately 15 nautical miles southeast of Greater Pittsburgh Airport. Shortly thereafter, at approximately 1609E, the Monongahela River was sighted and both engines ceased operating at approximately 3000' indicated. [REDACTED] Captain Jamieson transmitted a "Mayday" which was overheard at the Allegheny County Tower at 1609E on either 126.18Mc or 257.8MC. Major Dotson lowered wing flaps and completed a wheels-up touchdown, heading downstream in a generally south, southwest direction at approximately 1610E to 1611E. The ditching was successful and all occupants evacuated the aircraft with no apparent injuires. All six person were able to climb aboard the upper surfaces of the aircraft as it floated down the stream. The Monongahela River at this point varies from 800 to 1000 feet in width; the river depth varies from 25 to 35 feet. The current was estimated to be approximately 8 to 10 knots; the recorded water temperature was 35 degrees F; the recorded air temperature was 27° F; the recorded wind velocity was 8 to 10 knots, from the northwest. The aircraft remained afloat for an estimated 10 to 15 minutes. [REDACTED]

that the aircraft was sinking, [REDACTED] the crew and passengers to remove their shoes and swim to a log [REDACTED] floating nearby. [REDACTED] all six persons could swim. Sergeant Alleman, Airman Smith and Major Dotson reached the nearby log successfully. Major Dotson and Airman Smith remained with the log until recovered by a commercial river boat, approximately 15 minutes later. Master Sergeant Alleman reached the log but struck out for the left bank of the river [REDACTED] He was able to swim ashore with great difficulty and was assisted from the water by civilians and local police officers. Captain Jamieson used a small wooden post he found floating in the water as partial support and was able to remain afloat until recovered by a police launch. [REDACTED] Captain Ingraham [REDACTED] disappear beneath the water. Sergeant Soocey was [REDACTED] on some unidentified debris when last seen [REDACTED] Subsequently, [REDACTED] Sergeant Soocey swimming toward the left bank and disappear beneath the water approximately 60' from the shore. The aircraft drifted for an estimated mile from the point of impact prior to sinking. Major Dotson and Airman Smith, the last personnel to be recovered were recovered approximately 1½ to 2 miles from the scene of impact. At the time of this report neither the aircraft nor missing personnel have been located.

A partially blacked-out page of the official crash report of the B-25 that went down and disappeared in the Monongahela River in 1956. *Courtesy of the National Archives and Records Administration.*

continued, and on February 13, the Army Corps of Engineers brought in the *Redstone* to replace the *Monello II*, which was returned to Neville Island. The *Redstone* was an aquatic search vessel and was equipped with an "echo" depth recorder. Over two days, the *Redstone* searched from the crash site to the Emsworth Dam, 6.2 miles downstream on the Ohio River. After four sweeps with no success, the recovery operation was officially abandoned.

The B-25 that crashed in the "Mon," a North American Aviation B-25 Mitchell, was a medium bomber and one of the most famous types of warplanes used in World War II. The plane had a maximum speed of 275 miles per hour and a cruising speed of 230 miles per hour, with a range of 2,700 miles and a service ceiling at 28,800 feet. It had a wingspan of 67 feet, 7 inches and a length of 51 feet. Standing 15 feet, 9 inches tall, its gross weight was 35,000 pounds. While not a very large aircraft, it was a substantial size and should not have been very difficult to find in the Monongahela River under usual circumstances. The average depth of the "Mon" in the Pittsburgh area ranges between 20 and 25 feet, and it is between 800 and 1,000 feet across. The aircraft submerged in one piece. It could not have traveled downstream past the Emsworth Dam, and it is unlikely that it would have gone very far past the bends in the Monongahela River. After the extensive search conducted by the Coast Guard and Army Corps of Engineers, years of river traffic and dredging and countless hours of private searches, no trace of the plane has ever been found. Considering the fact that almost every other aircraft that has crashed into Pittsburgh's rivers has been recovered, one can understand why there have been so many questions about the plane's disappearance.

Rumors and theories about the crash and failed recovery began to circulate quickly and over the years would develop into the mythology that surrounds the crash today. Many witnesses, with varying degrees of reliability, have come forward over the past fifty years claiming to have seen the plane secretly removed from the river by the government in a covert nighttime operation. Some of these were J&L Steel employees living and working on Pittsburgh's South Side. A few even claim to have participated in the removal of the aircraft. One truck driver called the Perry Marshall show in the late 1970s claiming that shortly after the crash, he and two other drivers were recruited by someone he thought was a CIA agent. They loaded pieces of the recovered plane onto their trucks at the Coast Guard station in Sewickly and then drove them to a NIKE missile base in Oakdale, near Pittsburgh's airport. This story was supported by another man who contacted Robert Johns. The man, whom Johns called "Hal," was part of

the crew of the towboat *Zubik*. He stated that his crew helped to pull the plane out of the river and that it was subsequently cut up on the J&L dock and loaded onto barges. The barges were sent downriver to the Coast Guard station. The circulation of this story and others like it led to speculation that the plane was carrying some kind of secret or classified cargo. Otherwise, why would the government need to secretly recover the plane?

Naturally, given the era, there was suspicion that the cargo was some kind of nuclear weapon or device. This argument was circumstantially supported by the fact that the flight originated in Nevada, where nuclear development and testing was regularly occurring. The plane's second stop was in Oklahoma, where chemical weapons were being studied and tested in the 1950s. Some conspiracy researchers believe that one of these chemical weapons was the real cargo. Supporting the claim that the bomber was carrying chemical weapons was a discrepancy in the repair log. According to the crash report, the bomber had repairs made on its braking system in Oklahoma; however, the log shows no repairs being made on that day. A state-of-the-art communications system of some kind has also been mentioned as a possible cargo, though it is unclear where this idea originated. The addition of any weight to the plane after Oklahoma might also explain the bomber's fuel problem. Perhaps the crew miscalculated the factor that the additional weight would play in the amount of fuel needed to reach Olmsted. It has been pointed out, however, that the fuel loss seemed to occur suddenly during the last few minutes that the plane was in the air. The additional weight, if it was there, may have had no effect on the flight at all.

Other investigators believe that the "object" that the plane was carrying was actually a person. As mentioned earlier, there are reports by civilians who were present near the crash and rescue sites indicating the presence of one or more additional passengers than those listed on the official report. Unsubstantiated guesses as to the identity of the mystery passenger(s) have included a Russian defector or spy, the eccentric Howard Hughes and even a group of Vegas showgirls who were the "close personal friends" of the crew.

Many of those who believe in the conspiracy have combined the two theories, thinking that there was some secret agent or official escorting the secret cargo. The theory of government intervention and coverup has also been supported by claims of FBI involvement. According to James Cypher, captain of the *Titan*, the rescue boat that pulled Major Dotson from the river, several FBI agents met his boat at the dock and

huddled with the pilot in the corner before sending him to the hospital. Another secondhand report mentions a man who discovered the glass cockpit from the plane during the recovery attempt. He claimed to have been met by government officials who then instructed him to throw it back into the river. On the night of the crash, some hospital workers also claimed that they were told by government or military officials not to allow anyone in to see or question the crew.

Skeptics doubt most of the elements of the conspiracy theory. They insist that there would be many more reliable witnesses, even if the plane was recovered at night. A recovery operation would also be difficult to carry out in the dark. Why would the military waste time salvaging a B-25, a type of plane that was past its prime and of which they had a tremendous surplus? Even if it was carrying a secret cargo, wouldn't it have been easier to send divers to recover it rather than retrieve the whole aircraft? They believe that the plane, or what is left of it, must still be in the Monongahela River. It may have settled into a depression on the bottom of the river, where it was pushed down by barge traffic over the years. Some believe that pollution in the river could have dissolved the plane's aluminum skin and left behind only engine blocks.

Throughout the years since the crash, the mystery of the lost B-25 bomber has sparked the interest of various individuals and organizations. Most recently, the B-25 Recovery Group started a scientific investigation in 1995 in an effort to piece together the events surrounding the crash. Through use of side-scan sonar and historical sources, the group was able to formulate an explanation regarding the disappearance of the plane. The group believes that the plane is probably immersed in the forty-seven-foot hole located about one half mile from where the plane submerged.

In the years prior to the crash, a nearby steel mill was building new icebreakers that required forty barge loads of dirt and gravel. To acquire these materials, a hole forty-seven feet deep, about two hundred feet long and fifty feet wide was excavated in the river bottom. This pit had not been filled in at the time that the plane crashed into the river. The group believes that the plane probably hit the bottom almost immediately after submerging, and boats and the current created enough force to move the plane downstream. When the aircraft reached the open pit, it tumbled inside. The pit was identified and confirmed to exist by echo sonar at the time of the initial search, but no further investigation occurred. The group suspects that the aluminum frame has indeed dissolved but that the engine block, landing gear and other such pieces remain. The B-25 Recovery Group was

able to form a partnership with the Senator John Heinz Pittsburgh Regional History Center to help support the search. The two organizations used side-scan sonar and divers to search the hole and the waters around it. Despite several thorough attempts, no trace of the B-25 was found.

With time passing and witnesses growing older, the chances of discovering the truth are diminishing. During the Cold War, there were other documented cases of planes being secretly removed by the military. Yet the military continues to deny any knowledge or involvement in the removal of the B-25 that went down in the Monongahela River. Many believe that the only reasonable answer is that the plane remains in the waters of the Monongahela. Still, no trace of the plane has ever been found. Can a B-25 really disappear in twenty to twenty-five feet of water? Full-sized barges have been sunk and lost in the river, but detailed searches, such as the ones that were carried out for the plane, did not follow. Could the plane really have been removed at night? Could the removal have been done on one of the nights that the search was officially suspended? Why is so much of the crash report still classified? It is unlikely that we will learn the answers any time in the near future, and the truth, like the plane itself, will remain lost.

Gustave Whitehead: First in Flight?

Everyone knows that Wilbur and Orville Wright made the first successful machine-powered flight in Kitty Hawk, North Carolina, in December 1903. Their flight launched the age of aviation. Their first successful aircraft, the *Wright Flyer I*, is enshrined at the Smithsonian's National Air and Space Museum. It is a historical fact. Or is it? In the early years of aviation, there were many competing claims to the first flight. Some were more believable than others. What if someone else did fly first, and what if they did it in Pittsburgh? Surely such a claim would be investigated. If it were true, the pilot's name would be well known—unless someone had a vested interest in ignoring the flight. That is exactly what some promoters of the early aviation pioneer Gustave Whitehead believe.

Whitehead was born Gustav Albin Weisskopf in Bavaria in 1874. As a young man in Germany, he trained as a mechanic. He also spent time working on a ship. While at sea, he carefully observed wind and weather patterns. These experiences would later prove useful. By the time he came to America in 1895, he had developed an almost obsessive interest

From Out of the Sky Comes—Conspiracy?

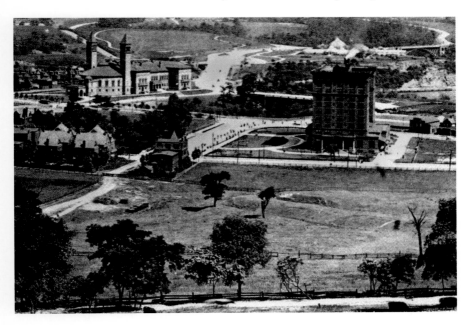

The Oakland neighborhood of Pittsburgh in 1900. Gustave Whitehead supposedly flew there the previous year. *Courtesy of the Library and Archives Division, Senator John Heinz Pittsburgh Regional History Center.*

in aviation and the possibility of building a successful machine-powered aircraft. Whitehead used his mechanical skills to find work while he developed his ideas. In 1897, while working in Boston, he was hired by the Aeronautical Club and publisher J.B. Millet to build (and presumable fly) advanced gliders. Several were constructed, but they only flew short distances and were ultimately deemed unsuccessful. Whitehead was not deterred and continued to design and build gliders in New York City and other places where he found work. By 1898, Gustave Whitehead was in Pittsburgh, and according to his supporters, he would soon make a major modification that would make his aircraft more advanced than any other.

While in Pittsburgh, Whitehead attached a steam-powered engine to one of his gliders. What he did with it is still a matter of debate among some aviation historians. Many have stated that the entire story is fabricated. Our main sources of information about Whitehead's Pittsburgh flight come from eyewitness statements given in the 1930s, many years after the event. According to an affidavit given by Louis Darvarich, Whitehead's friend and sometimes assistant, the primitive airplane flew briefly in the neighborhood

of Oakland in the spring of 1899. If what Darvarich said is true, then Whitehead should also be credited with the first plane crash.

Darvarich stated that both men were riding in the machine-powered plane. Whitehead was at the controls while Darvarich fed charcoal to the fire that heated the water in what was described as an "ordinary kitchen boiler." The firebox had asbestos on the bottom, clay walls and an iron lid. The engine had two cylinders. Neither of the men expected a successful first flight, and they were caught off guard by what happened next.

After the engine started, they quickly got the plane off the ground. As it charged forward, Whitehead steered the plane upward. Rapidly, they covered half a mile, exceeding expectations and the amount of open space for the plane. They were headed straight toward a new three-story brick house. Fearing that a quick swerve or sideways movement would cause the plane to crash, Whitehead decided to try to clear the top of the building instead. The aircraft could not climb fast enough, and it slammed into the side. The damaged plane crumpled to the ground.

Surprisingly, Whitehead was not seriously hurt. Darvarich was not as lucky. Steam from the boiler had scalded his leg. Fireman Martin Devine, who also gave his testimony of the event in 1936, was the first to arrive on the scene. He remembered someone being hurt and taken to the hospital. He also viewed a photograph of Whitehead and identified him as the pilot. Darvarich was supposedly taken to Mercy Hospital for treatment and remained there for several weeks. As a result of the accident, Whitehead was no longer allowed to test his aircraft in the city of Pittsburgh. He soon moved to Bridgeport, Connecticut, and continued his experiments.

In Connecticut, Whitehead supposedly made more successful flights before the Wright brothers. The first of the flights took place in August 1901, and it was covered by the *Bridgeport Herald*. His aircraft, known only as "No. 21," flew a distance of over twenty-six hundred feet at a height of almost fifty feet. That time, Whitehead brought the plane down intact. Eyewitnesses claim that he flew the plane three more times that day. The next flight was even more spectacular. On January 17, 1902, Whitehead flew "No. 22" over Long Island Sound. The craft had a kerosene-powered engine and, after flying a distance of two miles, was able to successfully land on the water, just off the beach. His assistants pulled the plane into shore. A short time later, he took off again. This time, he covered an incredible distance of seven miles and performed the first in-flight turn.

From Out of the Sky Comes—Conspiracy?

Despite the supposedly successful flights, Whitehead attracted little attention. Even though there were witnesses and even newspaper coverage, little stock was put in his claims. It was the age of yellow journalism, and many had come to distrust the press. The lack of interest may also have been due to the fact that he was an immigrant. Others just didn't believe him. According to statements given by two of Whitehead's helpers in the 1930s, there were at least two people interested in his work. Supposedly, the Wright brothers visited him twice in 1902 to learn about his lightweight engines. Naturally, the Wright brothers always denied this but did admit to being in Bridgeport at least once in 1902. Whitehead continued to develop aircraft and engines for years, but after the success of the Wright brothers, he fell into the background.

Whitehead may have been forgotten if it wasn't for an article written in 1935 in *Popular Aviation Magazine*. Stella Randolph and Harvey Phillips investigated his story and published "Did Whitehead Precede Wright in World's First Powered Flight?" Two years later, it was expanded into a book called *The Lost Flights of Gustave Whitehead*.

The authors assembled the few sources that we have today about Whitehead's early attempts at flight. However, aside from some radio and print publicity in the 1940s, there still seemed to be little interest in his story outside of a few aviation historians.

During the 1960s, retired Air Force major William O'Dwyer began to research Whitehead after discovering some photographs of his gliders. The major read Randolph's books and examined her research. He would champion Whitehead's cause in his book *History by Contract* in 1978. O'Dwyer learned from a friend in 1975 that the Smithsonian had made a special contract with the Wrights' heirs in 1948, when they acquired the *Wright Flyer I*. Rumors said that to get the plane, the Smithsonian agreed to ignore all other claims of flights before the Wright brothers. Through the Freedom of Information Act (and some help from a senator), O'Dwyer obtained a copy of the contract. Paragraph 2(d) read:

> *Neither the Smithsonian Institution or its successors, nor any museum or other agency, bureau or facilities administered for the United States of America by the Smithsonian institution or its successors shall publish or permit to be displayed a statement or label in connection with or in respect of any aircraft model or design of an earlier date than the Wright Aeroplane of 1903, claiming in effect that such aircraft was capable of carrying a man under its own power in controlled flight.*

It was right there in black and white. The Smithsonian, to acquire the plane, agreed that it would not acknowledge anyone as having flown before the Wright brothers. If it did, the plane went back to the family. In effect, any competing claims, regardless of evidence, were now struck from the historical record. The Smithsonian denied that it was aware of Whitehead's existence at the time of the contract, but O'Dwyer discovered that the Smithsonian's own publications mentioned him several times, and the institution's secretary, Samuel Langley, had visited Whitehead to examine his work. Langley had not thought that Whitehead's machine would fly, but then again, he was working on his own "Aerodrome" at the time. Langley also claimed to have flown before the Wright brothers.

Did the Smithsonian intentionally suppress the competing claims just to get a prized artifact, or was it confident that no one could have flown before the Wright brothers? To be fair, the current leadership of the Smithsonian has stated that it would in fact ignore the contract if enough evidence was presented otherwise. Whether or not he actually flew, Whitehead's contributions to aeronautics, especially in the area of engine design, were incredibly important. His engines served as models for many famous airplane designers around the world. His "Pittsburgh Engine" was adopted by Australian aviation pioneer Lawrence Hargrave in his early flights. Whitehead had over twenty aviation firsts, including individual control propellers, aluminum in engines, landing and take-off wheels, folding wings and using concrete runways.

Perhaps there is one final thing that should be noted. In both 1986 and 1998, reproductions of Whitehead's early aircraft were created. Both achieved flight. In 1986, Andy Kosch used his reproduction to fly *twenty* times and up to one hundred meters. The 1998 reproduction in Germany flew for over five hundred meters. Other aviation experts have determined that at least some of Whitehead's aircrafts were sound enough to fly.

Pittsburgh: First in Flight. Has a nice ring to it, doesn't it?

The Kecksburg Crash

Just before dark on December 9, 1965, a bright ball of fire streaked across the sky over the Great Lakes region of the United States and Canada. As it passed above six states, it left a trail of smoke that was visible for twenty minutes. Some aircraft pilots in the area thought that a plane was going

down. A seismograph near Detroit registered a shock wave. Across Ohio, fire departments were called as debris dropped from the object, causing small brush fires. NASA and the U.S. military claimed that it was a meteor that burned up as it entered the atmosphere. Some people in the Westmoreland County town of Kecksburg have a different explanation. They saw the object that was streaking across the sky slam into the ground near their small community at about 4:45 p.m. And that was only the beginning of the strangeness.

Many eyewitnesses came forth later to describe the falling object and what happened after it was on the ground. John Sibal described the object as making *S*-shaped turns as it came down. That would indicate some attempt at a controlled landing. Several volunteer firefighters saw the object fall, and not long after received calls that it had landed in nearby woods. Thinking that a plane had gone down, they divided into search teams and went looking. One of the teams, including James Romansky, came upon the object after following a trail of broken-off branches. What they discovered shocked them. It resembled no aircraft they had ever seen. Wedged in the ground at a thirty-degree angle was an acorn-shaped metal object, approximately twelve feet long and six feet in diameter. It had no visible openings; no hatches or windows. Those who saw it said that it was covered in strange hieroglyph-like markings around its base. The marks were described as stars, circles and other geometric shapes combined with letters that seemed like backward *K*s and *J*s. The craft seemed to have suffered no damage other than a dent, and there was no debris field.

It wasn't long before state police arrived to secure and quarantine the area. Everyone was told to leave, even the firefighters. When they returned to the fire hall, they claimed, military officials were everywhere. They had commandeered the station. Soon, more military vehicles arrived, one of which was a flatbed truck, and headed toward the crash site. By that time, more curious bystanders were trying to get close to see what was going on. One car full of teenagers, including Don Sebastian, said that they were turned away from the area by the police. Not to be deterred, they snuck around on foot and saw what they estimated to be close to one hundred soldiers near the object. Then they heard it—a terrible scream that they described as *not sounding human*. A few minutes later, they heard another and decided that they had better get out before they were caught. Other bystanders and curious teenagers were sent away by the military. Fourteen-year-old Michael Slater and his friend were asked to help by a soldier in a jeep. He told them

to give any visitors the wrong directions. Later that night, several of the bystanders saw the military vehicles come back up the road. The flatbed truck now had cargo. An acorn-shaped object covered in tarps was strapped to the bed of the truck. The remaining military personnel cleared out. The headline on the front page of the *Greensburg Tribune-Review* the next day read, "Unidentified Object Falls Near Kecksburg—Army Ropes Off Area."

Townsfolk in Kecksburg were not the only witnesses. John Murphy, a reporter for radio station WHJB, made it to the crash site before the authorities, after receiving many phone calls from concerned residents. He took some pictures and interviewed a few witnesses, but soon the military arrived and confiscated all but one roll of his film. His remaining roll of film contained a few images, including one of a cone-like object. In the weeks following the incident, Murphy conducted more interviews and was putting together a radio news special about the crash when he was visited by two men in black at the station. After the private meeting, Murphy's photos disappeared and his radio program about the crash was severely edited. He never talked about the crash again, and in 1969 he was killed while on vacation in California by a hit-and-run driver who was never caught.

Over the intervening decades, there have been several theories about what happened in Kecksburg that day. The official version was that a rather spectacular meteor came down, and it only appeared to crash. In actuality, it burned up in the atmosphere before impact. The reaction on the ground was just mass hysteria. For years, this was supported by trajectory calculations, based on photographs of the fireball and its smoke trail, which prove that the object could not have landed in Pennsylvania. In recent years, the calculations have been reexamined, and it has been determined that they were not correct. When properly adjusted, Kecksburg is along one of the possible trajectories.

There was also a theory that the object was actually a Soviet satellite. The Kosmos 96 Venus probe crashed after liftoff on that very day. U.S. Space Command and the Soviet Union both claimed that it went down over Canada, more than twelve hours earlier. But there is a possibility that part of the craft may have reentered the atmosphere later. Both superpowers purposely gave out false information regularly during the Cold War. The United States may have wanted to acquire the Soviet probe, and the Soviets most likely would not publicly admit that the Americans had snatched their technology. They claimed that it was faulty American equipment that had crashed. The Kosmos 96 had heat shields, some maneuverability and an

acorn-like shape. The strange hieroglyphs seen on the object may have been the Cyrillic alphabet used by the Russians, and the Red Star was one of their commonly used symbols. A Soviet satellite would explain the military presence and the secrecy.

The other popular theory is that the object was not from Earth at all. It was a UFO, piloted by beings from another world. The strange screams heard in the woods have been attributed to injured or dying extraterrestrials. James Romansky insisted that the writing that he saw on the object was not Cyrillic, or any other language that he had seen. Kecksburg authority Stan Gordon, who wrote and produced the ninety-two-minute documentary *Kecksburg: The Untold Story*, was contacted by several witnesses who claimed that the object was taken to Wright-Patterson Air Force Base in Ohio. One of the men said that he was working in a hangar where he saw a lizard-like creature that was partially covered. It was only days after the crash.

There has been a resurgence of interest in the case in recent years. In 2003, the Sci-Fi Channel, which was investigating the crash for a documentary, sued NASA to have files released under the Freedom of Information Act. On November 1, forty pages that contained little useful information were released. NASA still considered the object to be a meteor. After more pressure, NASA suddenly changed its mind in 2005 and claimed that the object was in fact a Russian satellite. It had examined debris that had fallen from the object during reentry, but the related records were lost in the 1990s. A court order in 2007 demanded that NASA find the records and release them. NASA again reiterated that two boxes of documents about the crash were missing. It is not clear why NASA suddenly recanted the story that it had upheld for years or whether the agency is telling the truth now. NASA's top expert on orbital debris, Nicholas Johnson, recalculated the path of the Kosmos 96 satellite in 2003 and claimed that it was impossible for it to have been the fireball or the object at Kecksburg. So if it was not Kosmos 96, what Soviet satellite was NASA talking about? Is the government still planting false information to hide its recovery of Kosmos 96? Was it even a satellite that crashed, or was it something else entirely—something from another world?

Right about now you should be hearing the theme to *The X-Files* in your head.

TALL TALES AND LEGENDARY FIGURES

Tall Tales and Folk Heroes

The American folk genre of the tall tale emerged during the early years of the republic and continued through the industrial era. The tales had their roots in the bragging contests that were common on the rivers and across the frontier. The big and wild country necessitated big and wild stories. The tales were usually loosely based on a real person or a real historical location, but they contained enormous exaggerations. Characters portrayed in the stories were in many ways superhuman and often had unbelievable physical attributes. Despite the obvious impossibilities, the stories were told as if they were fact. Often the tales contained elements of humor and related to difficult manual professions.

The names of the heroes of these tales are familiar to all of us—Paul Bunyan, Johnny Appleseed, John Henry, etc. Their oversized exploits are permanently entwined in the fabric of American legend. Western Pennsylvania has a few of its own legendary figures. Their stories are firmly rooted in both the frontier and industrial histories of the region.

Mike Fink: King of the Keelboaters

Half Horse, Half Alligator. That's what they called Mike Fink. Anyone who ran a keelboat on the Ohio or Mississippi knew his name. Of all the rough, hard-drinking, brawling river men, he was the toughest. He could drink a quart of whiskey and not even feel it. He would fight anyone and win. He could hit any target with his rifle, even from a moving boat. He was even a

rival of Davy Crockett. Mike Fink was infamous on the western waters, and he got his start in the original gateway to the west—Pittsburgh.

Mike Fink was an actual person, not just a fictional representation. There is some debate as to where and when he was born, but it is known that he spent part of his youth in Pittsburgh. Part of the confusion is due to the fact that there may have been two men named Mike Fink. The first was supposedly born in the early 1770s or possibly even earlier. There are several stories about Mike Fink's involvement in the Indian wars of the 1790s as a scout and a hunter. This Mike Fink was known for his courage in combat and his shooting skill. But this may not have been the keelboater, even though his life merged with the legend.

The other Mike Fink, the river man, is thought to have been born about 1780, either in Pittsburgh or possibly Maryland. His parents were German immigrants, and if they originally settled in Maryland, they had moved to western Pennsylvania by 1789. Even in his childhood, Mike Fink was a legend. Pittsburgh was a tough frontier town, but Mike Fink would prove to be tougher. He frequently fought with the other boys who lived around him. One particular boy, Sam McKillop, came back again and again, trying to beat him. Of course, he never could. Finally, this made Mike so angry that in their last fight he took the dishonorable course and bit off part of McKillop's nose.

In 1790, Fink's family bought land in North Fayette, Allegheny County. One of his first jobs was to run flour from a mill in Noblestown down Robinson's Run to the mouth of Chartier's Creek. There it would be loaded on keelboats and taken downriver. Through that connection, Fink eventually decided to work on the keelboats himself, first serving on a crew but quickly running his own.

The life of a keelboater was difficult. The keelboat age lasted from the early 1780s until about 1840, when they were replaced by steamboats. In the years after the American Revolution, the interior rivers, like the Ohio and Mississippi, and all their tributaries were becoming increasingly important to commerce. They served as highways through the dense wilderness. Flatboats and keelboats were used to transport goods quickly down the river. The problem was that flatboats, like most other boats at the time, could not go back upstream. They usually ended up being disassembled at their destination. Keelboats were different. Pointed at both bow and stern, these long and slender boats were designed with a keel that allowed them to sit high in the water and increased their speed.

A map of the rivers around Pittsburgh, 1816. *Courtesy of the Library and Archives Division, Senator John Heinz Pittsburgh Regional History Center.*

It also allowed them to be pushed back upstream against the current by a strong crew. Long poles were used to push off the river bottom or rocks. The strenuous and repetitive task made the keelboaters some of the fittest and strongest men on the frontier.

Mike Fink was the toughest of the keelboaters, and he proved it over and over again. He was over six feet tall and 180 pounds, which was large for the time. Fink was his boat's "champion." Every boat had a champion, often wearing a red feather in his hat to signify that he was the best fighter. The fights between boat champions could become brutal. Noses were broken, throats were crushed, teeth were knocked out and sometimes eyes were gouged. But no one on the rivers could beat Mike Fink, and he let everyone know it.

Fink was also legendary for his marksmanship. Called the best shot in the Ohio River Valley, Fink would supposedly shoot cups of whiskey off the heads of his friends, who were sometimes as many as seventy yards away. Once, he is said to have shot the tails off of three pigs from his boat sixty yards away. Other stories say that for fun he shot the scalp lock off of an Indian on a riverbank and the deformed heel off of a black man watching him from shore. In some versions of the scalp lock story, the Indian was hit and killed and Fink had to flee. For the latter shooting, he was arrested and forced to pay compensation.

The more word of Mike Fink spread, the taller the tales became. Stolen cargo, brutal jokes, shooting contests, womanizing and run-ins with the law all figured into the stories. There are different dates given for his main period of activity, but Fink was probably still working the rivers as late as 1815 or even 1820. Some versions say that about 1815 he went farther west because the Ohio River Valley was too civilized. He supposedly took his boat to the Missouri River, where he started trapping animals. By 1823, he had fallen in love with an Indian woman with whom his friend Carpenter was also in love. One day, Fink was performing his trick shot as he and Carpenter had done many times. Carpenter had a cup of whiskey on his head, expecting Fink to shoot it off. Instead, Fink purposely aimed too low and killed his friend. While drinking heavily shortly after the incident, he told their mutual friend Talbot what he had done. Talbot became enraged and shot Mike Fink through the heart, ending the career of the greatest of the keelboaters.

After his death, his legend only became larger. Fink was featured in popular fiction, dime novels and broadsides in the decades prior to the Civil War. He was often used as a villain or bully, facing off against the likes of

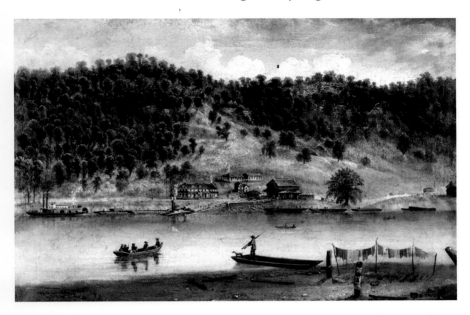

A drawing of the Ohio River near Pittsburgh in 1830. With the invention of the steamboat, the keelboat age was nearing its end. *Courtesy of the Library and Archives Division, Senator John Heinz Pittsburgh Regional History Center.*

Davy Crockett and others. While Fink's adventures were entertaining, he was not as heroic as his mythologized opponents in the eyes of Americans. In the late 1800s, his legend waned, though there have been periodic attempts at revival. Henry Shoemaker, ardent promoter of Pennsylvania folklore in the first half of the twentieth century, attempted to reacquaint the public with Fink without much success. Fink made two appearances on Disney's TV show *Davy Crockett* in 1955 and was part of a keelboat ride at both of its theme parks until the 1990s.

While not as popular today, Fink was well known in early America. He became a symbol of the hard life on the frontier and Americans' abilities to overcome all of the obstacles that it presented through dark humor and sheer force of will. In that sense, we can see why the real Mike Fink played the role of antihero before the stories made him a villain. He had traits that were necessary for survival, and that was respected, even if he would beat you up for not laughing at his jokes.

Judge Reddick v. the Devil

Little is known about the early life of John Hoge Reddick. He was born sometime between 1756 and the 1770s, possibly in Wheeling, West Virginia (then still part of Virginia), or Washington County, Pennsylvania. Some say that he fought in the American Revolution. Others claim that he was a colonel in the War of 1812. Two things are known for sure—he was an associate judge in Beaver County from 1804 to 1830, and he has one of the strangest graves in Pennsylvania.

Judge Reddick's grave straddles the West Virginia–Pennsylvania border. The lone tombstone sits just off of PA Route 168. The judge himself requested the odd location. It was part of his plan to protect his soul from the devil.

According to the legend, Reddick was known for being a fair judge and encouraging settlements that were acceptable to all parties. But horse racing, not law, was Reddick's real interest. He built a racetrack at his farm in Hanover Township and hosted races on a regular basis. Reddick participated in the races as well. His prize horse was said to be a large, fast and powerful gray stallion that brought him many victories. After one particular race that he won by a great distance, Reddick boasted that not even the devil could beat him in a race.

The story says that the devil (in some versions the demon Asmodeus) was not happy with Reddick's boast and was determined to punish him. He challenged Reddick to a race. If the judge won, the devil forfeited a large supply of gold. If the devil won, the judge forfeited his soul. Reddick couldn't pass up the opportunity to outrace the devil, so he agreed. They met at midnight on his track. Judge Reddick pulled ahead of the devil and his horse and it appeared that he would be victorious. But the devil wasn't about to play fair. His steed spit fire at Reddick's gray horse and the devil crossed the finish line first. The devil could now collect Reddick's soul when he died.

Reddick wasn't about to give up so easily. He spent the rest of his life trying to figure out a way to get out of the bargain. By putting his legal training to work, he came up with a solution. He left special instructions for the placement of his body. The judge was buried right on the Pennsylvania-Virginia line. When the devil came to collect, Reddick demanded extradition papers. The devil secured them from Pennsylvania and went back to Reddick's grave. The crafty Judge Reddick then rolled over to the Virginia side of his grave and demanded papers from Virginia. Of course, when the

devil came back, the judge rolled back over to the Pennsylvania side. This continued until the statute of limitations on their deal expired, and the devil had to renounce his claim. Apparently, the devil lacked access to surveying equipment because in the 1880s it was discovered that the grave was actually ten feet inside of the Pennsylvania boundary. It appears that Reddick tricked the devil twice by making him run back and forth securing papers when the second set was unnecessary.

There is an alternate version of the story that is sometimes told—one with a darker ending. In that version, the devil managed to secure extradition papers from both states simultaneously through trickery. He turned Reddick into a ghostly gray horse and rode him through Hanover Township at night. Some say that the evil laughter and thundering hooves can still be heard echoing through the woods.

Joe Magarac: Man of Steel

If there is one word that is permanently associated with western Pennsylvania in the collective American psyche, that word has to be steel. Even though most of the regional steel industry collapsed in the 1980s, its long shadow is still felt in obvious and not so obvious ways. For over a century, the mills were a source of both pride and contention. They provided economic opportunity to immigrant workers—a glimmer of hope that perhaps they or their children could escape the poverty and turmoil they had known in Eastern Europe. But the hours were long, and the work was hard and dangerous. Economic downturns could mean loss of wages or employment. Unionization ultimately meant conflict, sometimes violent, with management. Still, the millworkers produced the steel that built America and with it the modern world. Pillars of smoke no longer obscure the midday sun, but the legacy of the mills continues, even in folklore.

It would seem that the enormity and drama of the steelmaking process, with its blast furnaces and molten steel, would require a folk hero of equal stature. Joe Magarac was that hero. His story was first told in print in 1931, when *Scribner's Magazine* published an article titled "The Saga of Joe Magarac: Steelman." It was written by Owen Francis, who claimed to have heard the story from "hunkies" with whom he had worked for several years.

According to Francis, Joe Magarac was born in an iron ore mine, somewhere in the old country. He was seven feet tall and made of steel.

Steelworkers at the Jones and Laughlin Steel Company in 1900. *Courtesy of the Library and Archives Division, Senator John Heinz Pittsburgh Regional History Center.*

(Not metaphorical steel—actual steel.) He came to Pennsylvania to work in a mill town sometime around 1900. Magarac was able to perform incredible feats. He combed his hand through the molten steel to create rails. His powerful arms were compared to the giant mill smokestacks. He was good at everything in the mill and performed any job with a smile on his face.

Magarac's fame began the day of a special contest in his town. A man named Steve Mestrovich (sometimes described as the mill boss or foreman) was holding the contest to determine the strongest man in town. The prize was his beautiful daughter Mary's hand in marriage. The men had to lift three dolly bars, each heavier than the previous. Whoever could lift all three was the winner. Only three men made it to the final round, including Mary's true love, Peter Pussick. None of the men could lift the final bar. Just as it appeared that the contest was over without a winner, Magarac walked up and picked up the final bar and one of the other men. Since he had arrived late, Magarac did not know that he had won a prize. When Mestrovich offered his disappointed daughter to Magarac, everyone was surprised at his

Tall Tales and Legendary Figures

The J. Edgar Thompson Steel Works in Braddock, Pennsylvania, 1886. *Courtesy of the Library and Archives Division, Senator John Heinz Pittsburgh Regional History Center.*

response. Magarac could not have a wife because he worked at the steel mill twenty-four hours a day. When he left and went back to the mill, Mary ran off with Peter Pussick.

At the mill, Magarac worked harder and faster than all of the other workers. He produced so much of a surplus that the management had to shut down the mill. Depressed about being temporarily unemployed and separated from the work he loved, Magarac jumped into a Bessemer furnace to melt himself down. His body would provide steel of the highest quality with which they could build a new mill.

Many more stories would be attributed to Magarac in the years that followed. Often these tales involved his rescue of fellow workers. In one account, he saved them from a ladle full of molten steel that was about to split and burn them to death. In another tale, he caught a filled ingot mold before it crushed his co-worker. Magarac even stopped a runaway barge that was being pulled by a strong current. In all of the stories, he remained the most talented and efficient millworker anyone had ever seen. He loved making steel.

At first glance, Joe Magarac seems to be the ultimate steel mill hero. He is the Paul Bunyan of industry. By the 1940s, U.S. Steel and other corporations were using Joe Magarac as a company symbol. During the years of the Second World War, Magarac represented hard work, sacrifice

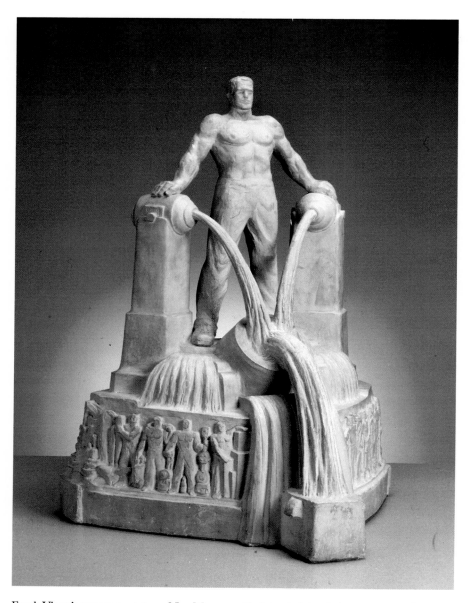

Frank Vittor's prototype statue of Joe Magarac. He intended the design to serve as the fountain at Pittsburgh's Point State Park. *Courtesy of the Museum Division, Senator John Heinz Pittsburgh Regional History Center.*

and patriotism. He appeared on company posters and in company publications. In 1950, he even had a comic book (produced by U.S. Steel) called *Joe, the Genie of Steel*. In the '50s, Magarac was even portrayed as the Americanized immigrant who had completely turned his back on the (now communist) East. During the Pittsburgh Renaissance in the 1950s, sculptor Frank Vittor suggested that a one-hundred-foot statue of Magarac, standing between three steel ladles that expelled water, serve as the fountain at Point State Park.

However, the 1950s also brought the first skeptical looks at the legend of Magarac. Some folklorists began to question why so many of the stories originated with the companies. When they looked deeper, they realized that before the media blitz about Magarac in the 1940s, most immigrant workers had never heard of him. Hyman Richman deemed the entire legend "fakelore" in 1953 after doing research in the mills. Magarac was not the ultimate hero for the millworkers; he was the ultimate employee for the corporation. He never stopped working, had no family to go home to, rarely ate and enjoyed doing the hardest jobs in the mill.

Traditionally, Magarac was thought to be Hungarian. After closer examination, it was realized that Magarac is only a word in Croatian, and it means "jackass." The stories explain this away by saying that he worked as hard as a mule. In actuality, the word was usually only used in a negative context. If the stories are read in a different way, Magarac can be taken as a fool who gave his life to the company and put the other men out of work. In that sense, the legend is actually a cautionary tale.

More recently, Jennifer Gilley and Stephen Burnett explored the negative aspect of the Magarac story by putting it in historical context. Their article "Deconstructing and Reconstructing Pittsburgh's Man of Steel" placed Magarac against the backdrop of the conflict between labor and management in the first half of the twentieth century. It became clear that the legend did not represent the goals and aspirations of the workers at all. The unions were fighting for shorter shifts, better wages and better working conditions. Magarac was a permanent fixture in the mill, regardless of pay or dangers.

But what of the hunkie workers who originally told the story to Owen Francis? Didn't they represent an authentic source? In his writing, Francis noted that the workers told him that the word magarac was a compliment. (They then said something in their own language and laughed.) The entire legend of western Pennsylvania's man of steel may have started as a joke played on a naïve writer.

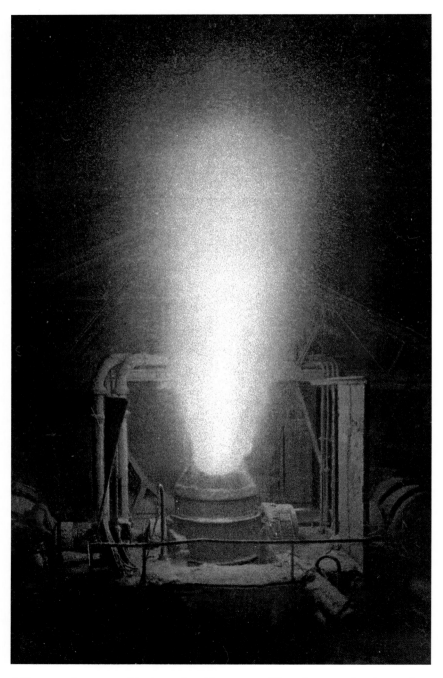

A Bessemer furnace used in the steel-making process. These furnaces played a part in many of the stories of Joe Magarac. *Courtesy of the Library and Archives Division, Senator John Heinz Pittsburgh Regional History Center.*

Tall Tales and Legendary Figures

In their research, Gilley and Burnett made note of the resurgence of the legend in recent years. They discovered that with the collapse of the steel industry, Magarac began to represent something different. In fact, the steelworkers began to identify with him as they lost their jobs. The legend finally connected to the workers. Magarac came to symbolize what the mills had been, the employment that they provided and the pride associated with them. Joe Magarac appears to have performed one final magnificent feat—he completed the strange journey from joke to fakelore to folklore.

THE GREEN MAN AND OTHER URBAN LEGENDS

Urban Legends in Western Pennsylvania

Urban legends are probably the most popular form of folklore in modern America. Professional folklorists prefer to call them contemporary legends because they occur just as often in suburban or rural areas as they do in the city. Everyone has heard them, whether they realize it or not. They often come directly from family and friends, by word of mouth or e-mail. Because the legends come from a trusted source, they seem more authentic. Situations and circumstances described in them are usually familiar and seem plausible when they are first heard or read. More often than not, they contain some kind of warning. Something you probably did not hear on the news. Some piece of information that might save your life or prevent some sort of harm.

Upon closer inspection, these "true" stories are full of misconceptions, distorted facts and details that just do not add up. The "trusted source" has usually heard the story from a friend of a friend, so the origin cannot be traced. Still, the legends resonate because they are typically set in day-to-day, normal surroundings. Even if an urban legend can't be proven, it carries an important message. Urban legends serve as cautionary tales and moral warnings. They are a natural expression of the fears, danger and uncertainty of everyday life.

The legends often reflect the fears of the time period in which they originate. In the 1940s and '50s, a story circulated about the Hook Man, an escaped maniac with a hook for a hand. He would attack young couples who parked their cars in secluded areas and lover's lanes. The real message was that premarital sex was risky and dangerous. In the 1960s and '70s, there was the couple who came home from a night out to find that the

baby sitter, who took LSD, had put the turkey to bed and the baby in the oven. This had a duel message. For young people, it showed the dangers of drug use. For adults, it was a reminder to be careful who they trusted to watch their children. In the 1980s and '90s, a legend circulated about a gang initiation that involved slashing shoppers' ankles in suburban mall parking lots. Gang members would wait under a car, and when the shopper returned they would cut her Achilles tendon and sometimes rob her. Besides the obvious fears of gang violence, that legend is a reminder that no place is completely safe.

While the previously mentioned legends and many others made their rounds in western Pennsylvania, they also circulated nationwide. Many of the urban legends that are unique to the region fall into the specific subcategory of "legend trips." Legend trips are a form of interactive urban legend. Often taken by teenagers, though anyone can be involved, they can be viewed as a rite of passage. Legend tripping involves traveling to a remote or isolated place, almost exclusively at night, where some supernatural event is said to occur. Often it is the site of some sort of actual or perceived tragedy or accident. By going there and performing some sort of ritual, like flashing headlights three times, putting your car in neutral, etc., the legend tripper triggers a supernatural response and therefore becomes part of the legend. By challenging the danger presented by the legend, those on the legend trip prove their bravery, even though the whole activity is usually quite safe.

The legends that will be discussed here all contain aspects of the legend trip, as well as some elements of more traditional urban legends. It seems that western Pennsylvania is blessed (or is it cursed?) with many legend trip sites. Those included here are just a few of the more prominent.

The Green Man (aka Charlie No-Face)

Since the 1950s, no urban legend has been as persistent in western Pennsylvania as that of the Green Man. He is the region's version of the Hook Man, stalking back roads and secluded areas, waiting to frighten teenagers and anyone else curious enough to seek him out. Some say he is a man; others, a ghost. The stories about him are as varied as the places he is said to appear, but all begin the same way. In all of the versions, he starts out as a normal boy or man. Then tragedy strikes. He is struck by lightning. He is electrocuted while climbing a utility pole to untangle a kite.

The Green Man and Other Urban Legends

He was an industrial worker who fell into a pool of acid. The list goes on and on. Whatever the cause, the accident left him disfigured and with a strange green glow.

The Green Man, or his ghost, is said to haunt a variety of locations in the area. In Allegheny County, he appears in North Park, West Mifflin, McKees Rocks and Brookline, among other places. In Beaver County, he is spotted around Koppel and Darlington. He has been placed as far south as Washington County and as far north as the New Castle and Youngstown areas. The most popular home of the Green Man is in South Park, Allegheny County. The glowing green ghost supposedly inhabits the old B&O Railroad Tunnel on Piney Fork Road. The curious make frequent nocturnal trips to the tunnel, hoping to catch a glimpse of the elusive figure and have some kind of experience with the supernatural. The locals say that the Green Man was electrocuted in a stream that runs nearby, although no one is sure exactly how. Now his green ghost inhabits the old tunnel, driving away all who disturb him.

According to the story, there are several ways to make the Green Man appear once you have reached the tunnel. Some versions say that if you pull up close to the tunnel and blow your horn three times he will appear. Other versions say that flashing your headlights or a flashlight three times will summon him. Calling his name three times is said to work. In some versions of the legend, he will only appear during a thunderstorm. A green mist will surround anyone who lingers too long, and when he does appear, no one stays around long enough to see what will happen next. The Green Man is also said to wander on nearby Snowden Road late at night, approaching any car that stops or parks for more than a few minutes.

The legend trip elements and similarities to the Hook Man are clear in this legend. But why is the legend so widespread? The reason may be that unlike many of the other urban legends, the Green Man was real or at least based on a real person. Unlike the legend, he was no ghoul. In fact, he was quite the opposite, but his story was every bit as, if not more, tragic. His real name was Ray Robinson.

Robinson was born in 1910 in Beaver County. His early years were spent in the Morado section of Beaver Falls. He had a fairly normal childhood for his first nine years, until one horrible day in 1919. On a warm day in June, Robinson and his friends were on their way to go swimming near the Beaver River. Their route took them near the wooden Harmony Line trolley bridge that ran over Wallace Run (now the Route 18 highway bridge). The bridge

had electrical lines that carried a high voltage, and a year earlier a boy had been killed on the bridge after touching one of the lines. But the friends had seen a bird's nest on the bridge the day before, and they wanted to see how many eggs were in it. Robinson volunteered to climb up, and at some point he touched an active line. He was burned and shocked so badly that no one expected him to survive.

Robinson did survive, but the top half of his body was burned and disfigured. He lost his left arm below the elbow. His eyes and nose had been burned away. The rest of his face and ears were distorted. He had only a few patches of hair left on his head. After months in the hospital and numerous surgeries, he went home. Despite his horrific injuries, Ray maintained a positive attitude and did not dwell on his injuries.

At home, Robinson kept himself busy listening to the radio and following baseball in the summer. Some of those who met him said that he could rattle off any statistic or score. Robinson also made things like doormats and belts. When he went outside, he often walked the familiar trails that were behind his house, keeping one foot on the path and one foot off the edge so that he never lost his way. When the land behind his house was strip mined, Robinson was forced to find a new place to take his walks. It was then that the legend began.

His new walking path was Route 351, the Koppel–New Galilee Road. He walked at night, usually between 10:00 p.m. and midnight, because he didn't want to attract attention. But despite the late hour, people found Robinson anyway. It started in the 1950s with teenagers who would drive past Robinson and stare in horrified fascination. They would tell their friends, who would tell others. Soon, Robinson had little peace on his nighttime walks. Sometimes he would try to hide behind trees or move away from the cars; other times, there was nowhere to go. They called him "Charlie No-Face." By the late '50s, Robinson was getting visitors from as far away as Chicago. On Friday nights, it was not unusual for dozens, and occasionally hundreds, of cars to drive up and down the road looking for him. "Charlie No-Face" had become a legend trip even before Robinson's story turned into the legend of the Green Man.

Jim Matuga grew up in Beaver County and made frequent trips to see "Charlie." He befriended Robinson, whom he described as a "kind and friendly man." Robinson allowed Matuga to take his picture before he went into the military in 1959. Matuga remembers that while some visitors treated Robinson well, other visitors were not so kind. Some would give him beer and cigarettes, leaving him intoxicated on the side of the road. Others even tried to beat or attack him. Robinson was found on the side of the road or

The Green Man and Other Urban Legends

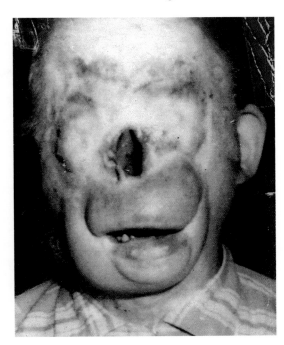

Ray Robinson, also known as Charlie No-Face, in 1959. His horrific injuries inspired the urban legend of the Green Man that spread throughout western Pennsylvania and beyond. *Courtesy of Jim Matuga.*

in nearby fields more than once after being missing all night. One night in August 1958, a couple who had just been married stopped to ask Robinson for directions to a local hotel. He kept his back to them as he talked, but they couldn't hear him. When he leaned down toward the car window, the bride became so frightened that she supposedly went into cardiac arrest (or at least had a severe panic attack). Their car sped off. Local television reporter Bill Burns interviewed the terror-stricken husband. He said they had encountered a Martian.

Robinson walked the road for over thirty years. Near the end of that period, it seems that some of the visitors began calling him the Green Man. This is especially true for those who were from outside of Beaver County and unfamiliar with his story. One explanation given for the name was that he wore a specific type of shirt or jacket that seemed to reflect a green glow when in headlights. Another is that he just wore green clothing or a jacket. At least one account says that his scars or damaged skin had a very light mint green look. Regardless of the origin, the name stuck, and the legend soon spread throughout the surrounding counties. As people moved away and passed the story down to other generations, the details became fuzzier and the locations started to change. Younger

people would hear parts of the story and inadvertently adapt it to their own area. The Green Man took on a more sinister and supernatural aura, in most cases becoming a ghost.

Ray Robinson died at a nursing home in Beaver County in 1985. By that point, he had long since stopped walking the Koppel–New Galilee Road. But his legend has never stopped walking. As long as people continue to seek out the Green Man, it probably never will.

Blue Mist Road

In the North Hills area of Allegheny County, there is a particularly creepy urban legend that has been recounted at least since the 1970s. The legend of Blue Mist Road is well known in the townships around North Park. Versions of the story have been passed along for decades through friends, schools and now the Internet. The stories seemed to have reached the peak of their circulation in the 1980s and '90s, although they are still told today. As a result, the journey to Blue Mist Road became one of the North Hills' most popular rites of passage.

Blue Mist Road is not its real name, of course, but it is far more ominous sounding than Irwin Road. Located to the east of North Park Lake, Irwin Road runs from Babcock Boulevard to Route 910. The half of the road that connects to Babcock Boulevard isn't marked and is closed to traffic. It is the closed half that is traditionally thought of as Blue Mist Road. The paved but crumbling road follows Irwin Run through a wooded and strangely secluded area. Despite the proximity to North Park, a neighborhood, and fairly busy roads, the whole area seems eerily isolated. It is the perfect place for a legend trip.

Several gruesome stories are told about the road. Some of the earliest accounts say that somewhere just off to the side was a meeting place for the Ku Klux Klan. Nearby was a "hanging tree" that was used for lynchings. Several victims were allegedly found there, still hanging from the tree. There is one way to identify the tree from the hundreds of others that line the road—it bleeds when the moon is full.

The most popular story is that the road is a meeting place for a satanic cult or a witch's coven. If one travels to the road at night, he may stumble across the dark ceremonies and find ritually slaughtered animals in pentagrams of chalk or blood. Of course, animals were not the only thing sacrificed on the road. In some versions, the cult sacrificed virgins. Some say that on

The Green Man and Other Urban Legends

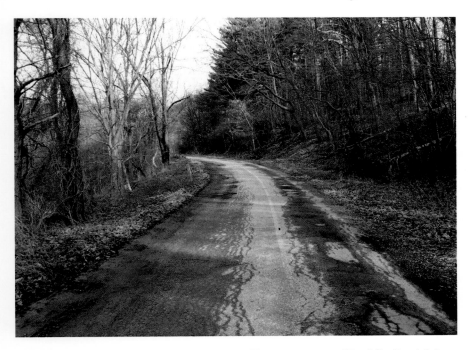

Irwin Road near North Park, Allegheny County. Known to many as Blue Mist Road, it has been a legend trip destination for decades. *Author's photo.*

certain unholy nights of the year, large bipedal hoof prints can be found in the mud near the ceremony site. Others claim that the hoof prints can be seen in the snow during a full moon. The prints may be those of the devil himself, or they may belong to a creature, half man and half deer, that also stalks the road.

There is said to be a lone house by the road that was used by the cult. One particular account that was passed along by the friend of a friend of a friend (so it must be completely trustworthy) detailed the encounter that a few high school students had with a cult member at the house. The incident happened about 1990. The three students drove down Blue Mist Road to find a spot where they could stop and drink the beer that they had recently acquired. They stopped in the woods near an old vacant house. After a while, they noticed the light of candles through the dark windows. On a dare, one of the young men went up to the front door and knocked. It quickly swung open, and standing there was a large bearded man in black robes. He told the young men that if they left now and kept their mouths shut he would pretend that this did not happen. Needless to say, the boys left as quickly

The lone mailbox on Blue Mist Road. *Author's photo.*

as possible. The story is typical of the kind heard about Blue Mist Road. However, there is actually no house on the closed portion of the road, only a lone mailbox.

The satanic cult element of the story emerged during the nationwide scare over satanic ritual abuse during the 1980s, sometimes referred to as the "Satanic Panic." A few psychologists and law enforcement officials used highly questionable methods that are now discredited to suddenly uncover thousands of cases of physical and sexual abuse conducted by alleged cults. The media fed the hysteria with lurid (and false) accounts. The cults were everywhere, often in day-care centers and schools. Satanic messages were being "discovered" in places such as children's games and on records when played backward. Eventually, the fear subsided, but the panic left a lasting impression in the urban legends and folklore of the 1980s. The legend of the cult on Blue Mist Road overshadowed the tales of the Ku Klux Klan. The Klan had been a more relevant boogeyman in the late 1960s and '70s because of the lingering impact of the civil rights movement and unresolved racial issues.

As if the KKK and a satanic cult were not enough, we cannot forget the reason why Irwin Road received its spooky alternative name. A mysterious blue mist sometimes surrounds cars and people that venture onto the road. If a driver goes far enough down the road, the mist will come and cause the car to stall. Another legend involving cars relates to an accident that allegedly happened many years ago. A family was taking a shortcut down the road when a drunk driver (or deer) caused them to swerve off of the road and into a tree. The entire family was killed. If you drive halfway up the road and put your car in neutral, the ghosts of the dead family will push your car back in the direction that you came.

Finally, there are supposed to be two tombstones along the road, those of a husband and a wife. When the moon is full, they move closer together and touch. While most versions of the legend place the graves on the road, they are actually located in the cemetery on Route 910 that is directly across from the end of Irwin Road. The tombstones are actually moving closer together, but it is because the ground is sinking. Do not be disappointed at the mundane explanation, though—an alternate version of the grave story says that when the stones touch, the world will end.

Zombie Land

Another rumored home of the Green Man and the Hook Man is a desolate old industrial area that has been given the ominous name of Zombie Land. Located off Route 224 in Mahoning Township, Lawrence County, it is situated between New Castle and Youngstown, Ohio. Zombie Land has an evil reputation in local folklore. Covering almost two square miles, it is probably western Pennsylvania's largest legend trip site.

There is not one but several different legends associated with the site because of its large size. Before entering the area, visitors should make a stop at the old Saint Lawrence Church, which is now apartments, at the corner of Route 422 and Churchill Road. Outside the building is a statue of the Virgin Mary. Legend says that if the hands of the statue are open, it is safe to enter Zombie Land. When the hands are folded, she is praying and it is too dangerous to enter. The hands have always been folded. (They were carved that way, of course.)

One of the legends associated with the area involves an old graffiti-covered bridge. It is locally referred to as the "Puerto Rican Bridge" or the "Frankenstein Bridge." It was called the Puerto Rican Bridge because

many of the earliest names painted on the bridge were Hispanic. At least one young man, and possibly more, is said to have committed suicide on or under the bridge decades ago. Rumors say that if your name appears on the bridge, you will soon die. How this happens depends on the version of the story that you hear. In one version, it is just a curse, and the person will die in a freak accident or because of some act of violence. In the more popular version, zombies or some kind of demented ghoul-like creatures will rise up from under the bridge and hunt down the unfortunate victim. It is the curse aspect that makes this legend unique. While many legend trips contain omens of death, they are usually not directed at a third party. The interaction with the supernatural in this legend trip can be rather malicious.

Nearby the bridge is an old natural gas well that is said to still leak gas. It provides another method for summoning the zombies. According to the legend, if the leaking gas is lit (*which is very dangerous and should never be attempted under any circumstance!*) it attracts the zombies, who will chase anyone near the well. In some variants of the story, the lit well attracts the ghost of the Green Man.

Zombie Land also has a witch, or at least her ghost. She lived in an old house that was abandoned years ago. It was referred to as the "Blood House." The house burned down sometime in 2001 or 2002, but the foundation still remains. Legend says that the witch kidnapped and murdered young children. She would use them as sacrifices in her dark ceremonies. The children's corpses are supposed to be buried in the fields around the house. If you go to the house and stay too long, the ghost of the witch will try to possess you so that she can claim more victims. The ghosts of the children will try to prevent you from entering the ruins of the house. If you approach the house and put your car in neutral, the children's ghosts will push it backward and away from the house. Of course, there are no police reports concerning large numbers of missing children in that small area, and for that matter, there are no reports of zombie attacks either. It is most likely that the witch portion of the legend was added during the previously mentioned Satanic Panic of the 1980s.

Reports of both the Green Man and the Hook Man approaching parked cars or walking down the side of the road are common in Zombie Land. It is not surprising given the variety of legends in the area. The original Hook Man, the *real* one, is said to have lived in a house there, but no one can seem to find exactly where.

Maybe they couldn't make it past the zombies.

Thirteen Bends Road and More Legend Trips

There seem to be legend trip destinations scattered all over western Pennsylvania. While there is no way to include all of them here, there are a few more good examples of the ritualized activity that are worth mentioning. What better place to begin than with the infamous 13 Bends Road.

Thirteen Bends Road

If you are seeking out legends in Harmar Township, Allegheny County, you need go no farther than the end of Campbell's Run Road. Past the end of the paved road there is an old dirt mining road that snakes and bends thirteen times. Once you pass the final bend, there is a small path that leads to a clearing that was once the site of a tragic fire. According to the story, there was an orphanage that once stood on the site. Many years ago it burned, killing all of the children inside. If you are quiet and listen, you can hear the children whispering. Sometimes you will find tiny handprints on your car, especially if it is dusty or dirty.

While no orphanage actually existed on that site, there was once a barn nearby that doubled as a dance hall. It burned sometime in the 1940s, but there were no known fatalities. It may have been the inspiration for the legend.

McConnell's Mill

Along Slippery Rock Creek, in Lawrence County, is McConnell's Mill State Park. It is named after the scenic old mill that is its centerpiece. Nearby, stretching over the creek is a ninety-six-foot-long wooden covered bridge that was built in 1874. Both of the structures have urban legends associated with them.

Constructed in 1868, the mill was used to process grain from the surrounding farms in the county. By 1928, there was no longer enough business and the mill had closed. The mill and the property surrounding it became a state park in 1957. In the years between, the mill was watched and maintained by a caretaker named Mose Wharton. Wharton had worked in the mill before it closed and stayed around to take care of it. He protected the site from vandals and those who came to steal parts or lumber. Wharton was known to be very helpful to visitors who came to learn about the old

McConnell's Mill alongside Slippery Rock Creek, 1952. *Courtesy of the Library and Archives Division, Senator John Heinz Pittsburgh Regional History Center.*

mill and appreciate its history. He even rescued several people who almost drowned in the dangerous waters of the creek. In 1952, Mose Wharton left the mill he loved, and it was soon taken over by the state. According to the legend, he didn't leave for good. If you approach the mill late at night and blow your car horn or cause some other kind of disturbance, the club-wielding ghost of Wharton will chase you off of the property.

The covered bridge has a different legend. At some unidentified time in the past, two Amish boys were said to have drowned in the creek near the bridge. (Slippery Rock Creek has claimed many lives over the years.) To interact with the supernatural there, you must stop your car in the middle of the bridge at night and open up your back doors. When you look in the rearview mirror, the boys will be in the backseat. When you turn around, they will be gone, but the seat will be wet.

The Green Man and Other Urban Legends

The Wetman

In the town of Hooker in Concord Township, Butler County, the ghost of a drowned man will appear in your car. The legend is similar to that of the covered bridge at McConnell's Mill; however, the man did not drown in the usual fashion. He died near an unspecified railroad. The "Wetman" had been drinking heavily when he climbed up onto the trestle. He moved too close to the tracks and was bumped by an oncoming train. The force threw him off the trestle and into a nearby stream. Although the impact wounded the man, his injuries were not fatal. The water in the stream was only a few inches deep, but the combination of alcohol and his injuries prevented the man from getting up. He soon drowned in the stream. If you can locate the site of the accident and pull up close to the stream late at night, the man will appear in your rearview mirror as if he is in the backseat of your car. If you reach back and feel the seat, it will be wet.

The Bleeding Tunnel

In West Mifflin, Allegheny County, there is a frightening tunnel on Curry Hollow Road. Most versions of the story say that a man was murdered (usually stabbed) in the tunnel years ago on a rainy night, and the crime was never solved. Today, if you pass through the tunnel (which is really more of an underpass) when it rains, your car may be splattered with tiny red droplets of the man's blood that seep up through the ground. It is a reminder that his killer was never caught. Or it could be a sign that all of the rusty pipes and metal in and around the bridge above should be replaced.

Corvette Tunnel

Just around the corner from the Green Man tunnel in South Park is Corvette Tunnel. Some time in the late 1970s, a young woman in a Corvette was said to be racing another car near the tunnel. When she entered the narrow tunnel, a car was coming in the opposite direction and collided with the young woman. She was killed instantly. If you go to the tunnel at midnight, you will supposedly hear screeching tires and screams.

PART V

GHOST STORIES

Ghost Stories and Community Memory

Everyone loves a good ghost story. Whether you believe or not, a good ghost story will leave you taking a second look at that shadow you see out of the corner of your eye or make you listen a little closer to see if you just heard what you thought you heard. Tales of ghosts and hauntings are everywhere in western Pennsylvania. There are literally hundreds. While on the surface, ghost stories are entertaining, they often serve another purpose as well. Ghost stories can represent a form of community memory in disguise. They can be a kind of popular or social history that recalls events in a different way or from a different viewpoint than traditional history.

Sometimes stories of hauntings reflect fears and recount tragedies that affected a community. They can even signify a lack of resolution for an event. Ghost stories may represent people who would otherwise have been forgotten or serve as a form of spoken or written memorial. These tales differ from urban legends because they are rooted in actual historic events tied to a specific location, though sometimes details become fuzzy and facts distorted.

Western Pennsylvania's long and interesting history has made the region fertile ground for ghost stories. It has also helped that the region has a stable, multigenerational population that has passed down the stories. The ghost stories in this chapter can all be interpreted as community memory, whether it is something good, like Maxo Vanka's murals, or bad, like the Chautauqua Lake Ice Company fire. If you choose to visit any of these places, keep your eyes open because you just might have a little "interactive" history.

Maxo Vanka and the Millvale Ghost

The story of the apparition that appeared to the artist Maxo Vanka in Saint Nicholas Croatian Roman Catholic Church is one of the most circulated ghost stories in western Pennsylvania. The church itself is located in the Pittsburgh suburb of Millvale. Most of the Croatian immigrants who arrived in western Pennsylvania in the late 1800s and early 1900s settled in Millvale and other nearby Allegheny River towns such as Allegheny City (later Pittsburgh's North Side) and Etna. Saint Nicholas was constructed in 1900 to meet the needs of the growing number of immigrants. About 10 percent of all Croatians in America lived there, so the congregation was large. A fire damaged the inside of the church in 1921. Insurance paid part of the repair cost and the parish paid the rest.

By 1937, Father Albert Zagar, the pastor, had paid off the church's debt and was looking to improve the interior of the building. He wanted to have new murals painted on the ceiling and walls. Zagar had seen and admired the work of Croatian artist Maxo Vanka during an exposition in Pittsburgh several years earlier. He had hoped to bring the artist to his church to do the work but was unsure how to contact him. He sent a letter to Louis Adamic, a Slovenian writer living in New York City, thinking that Adamic could help find Vanka. As luck would have it, Adamic and Vanka were friends, and the letter found its way to the artist.

Vanka was born in Zagreb, Croatia, in 1889, possibly the illegitimate son of a noble. He developed a love for art at an early age and eventually attended the Royal Academy of Beaux Arts in Brussels, Belgium. During the First World War, he served in the Belgian Red Cross rather than fight and remained a lifelong pacifist. The carnage he witnessed would have a lasting impact on his work. After his service, he returned to Croatia to teach art. His works became well known in Europe and were displayed in many institutions. In 1931, Vanka married Margaret Stetton, the daughter of a prominent New York surgeon. They moved to New York in 1934, but Vanka had difficulty selling and promoting his art in America. The invitation to paint Saint Nicholas was welcome news.

The beautiful, and sometimes disturbing, murals that Vanka painted in the church secured his fame in America. They are full of powerful and sympathetic imagery depicting the horrors of war, the hardship of life for the immigrants and the faith that sustained them. They reflect much of the personality of Vanka. Those who knew him described him as having the "gift of sympathy." He was known for sensing the pain and troubles of

Maxo Vanka's mural depicting pastoral Croatia in Saint Nicholas Catholic Church in Millvale. It is one of the murals he was working on when he saw the apparition. *Courtesy of Kerry Crawford.*

others. Wild animals were said to approach Vanka and eat out of his hands and pockets, feeling perfectly safe.

Perhaps it was his gift of sympathy that allowed him to see the ghost while he was working on the murals. Vanka usually painted at night, and he insisted that he not be disturbed. Even Father Zagar did not enter the church while the artist was painting. While on top of the scaffolding, Vanka began to hear noises from the church below. Initially, he attributed them to his imagination or normal noises that he was not yet accustomed to. On the fourth night of work, he looked down and saw a robed figure making movements with its arms. Vanka thought that Father Zagar had come in and was being silent so as not to disturb him. He ignored the figure and went back to work, although he did notice that Father Zagar's dogs began to bark loudly outside. Vanka finished his work and left the church about 2:00 a.m. Father Zagar had coffee and cake waiting for him. When asked about his whereabouts, Zagar said that he had not gone into the church. Vanka did not put much more thought into the incident.

Several days went by before there was another occurrence. On the eighth night of work, about midnight, Maxo Vanka looked down from the scaffolding and saw the hooded man again. The strange figure was making gestures with his arms and mumbling as he walked up and down the aisle of the church. Vanka felt a strange chill rush over him as he hurried to finish his work. By the time he was done, about 12:30 a.m., the man had disappeared.

Immediately, the artist headed for the rectory, where he found Father Zagar asleep. He had apparently been there for several hours. Vanka thought that the priest might be sleepwalking, but Zagar dismissed the idea. Then Zagar told Vanka about a story that had been circulating at the church for about fifteen years. Several parishioners claimed to have had encounters with a ghostly figure in the church. There were even arguments about the nature and identity of the ghost, but no one had come to any real conclusion. Father Zagar had never personally seen the apparition. He had refrained from telling the story to Vanka because he was afraid that he would scare himself and fall from the scaffolding. The two then decided that at 11:00 p.m. each night Father Zagar would come into the church and stay with Vanka until he finished.

The next night, when the priest entered the church, he began to make jokes about the ghost. His jokes soon ceased when he and Vanka began to hear loud knocking sounds coming from the back of the church. Father Zagar walked toward the noise and said, "If you're a ghost, if you're a dead man, go with God. Peace to you. I'll pray for you. Only, please don't bother us." Just then, Vanka saw the apparition materialize in the fourth pew. According to the artist, he was an old man with a strange, angular face. Within seconds, he disappeared. Father Zagar had not seen the ghost and was still a bit skeptical. His skepticism disappeared later that night after he had gone to bed. He began to hear loud knocks in his own room, similar to the ones he had heard in the church. He also felt an unnerving chill and sensed the presence of a dead man. Zagar prayed for the ghost's soul and again asked him to allow Vanka to work in peace.

Several nights passed without incident, and Father Zagar began to believe that the ghost was honoring his request. Then the knocks started again. Zagar again went to the back of the church to investigate the noise. Vanka, who was still on the scaffolding, saw the ghost materialize in the aisle. The apparition proceeded up to the altar and the eternal flame. When he reached it, he blew it out and then disappeared. The light had not been extinguished since the day it was lit eight years earlier and was surrounded by glass that

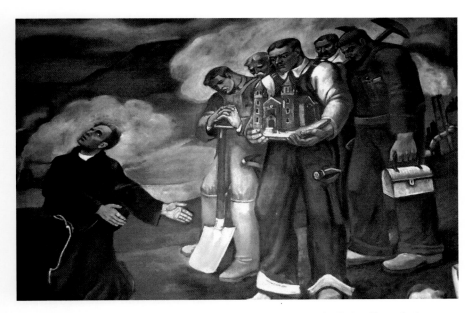

Another Vanka mural depicting the Croatians coming to Millvale. Father Zagar is the kneeling priest. *Courtesy of Kerry Crawford.*

protected it from the wind and drafts. Father Zagar had not seen the ghost but turned around in time to see the flame go out. From that time on, he never doubted a word of Vanka's story.

The ghost continued to appear over the next few months while Vanka was working. The artist was often filled with feelings of dread and fear just before the ghost appeared. Sometimes the feelings were so strong that he fled the church. Vanka began stuffing his ears with cotton and wearing blinders made of newspaper to try to block out the presence of the ghost. The entity usually appeared between 11:00 p.m. and midnight. One evening in June, the ghost appeared early. About 9:00 p.m. it somehow ignited several candles near the altar. Vanka did not touch the candles and let them burn down naturally.

Vanka finished his famous murals shortly after the candle incident. Soon, he recounted his experiences to his friend Louis Adamic. Adamic wrote a ten-page account of the haunting for *Harper's Magazine* in 1938. Though he believed Vanka was telling him the truth, Adamic thought that Vanka may have created the apparition in his mind because of the stress of the deadline (or perhaps as a subconscious excuse if he failed to meet it). It has been speculated that Adamic crafted or exaggerated the story to gain

publicity for his friend. While Adamic certainly may have used the story for publicity, Vanka truly believed that he was visited by the ghost. Maybe his "gift of sympathy" extended to the dead as well as the living. In 1941, Vanka returned to Saint Nicholas Church to paint a second set of murals that was even more powerful than the first. During that stay, he had no encounters with the ghost. Maxo Vanka's beautiful and haunting murals can still be seen on the walls and ceiling of the church today.

Dead Man's Hollow

The rivers of western Pennsylvania have been an integral part of the region for over two and a half centuries. They have been a vital source of wealth, commerce and development. They also suffered as a result of years of heavy pollution. In recent years, the rivers have been revitalized, and much of the area around them has been turned into trails and public parks. The Youghiogheny River Trail is one of those improvement projects. There are two stops on the trail that are especially interesting, not only for their scenery, but also for the supernatural folklore that is associated with them.

Dead Man's Hollow is located along the trail in Lincoln, Allegheny County, just across the river from Versailles. It is the largest unbroken wooded space in the county. Over one hundred years ago it was home to several industries, including two brickworks, the Union Sewer Pipe factory and several gas and oil wells. The area has since been turned into a four-hundred-acre nature preserve complete with hiking trails and wildlife. The only traces of industry that remain are the burned-out ruins of the sewer pipe factory. However, there are some traces of the hollow's past that have not disappeared so easily. The phantoms of those who died in the hollow haunt the preserve, occasionally being seen and heard. The legends of the hollow may have faded into obscurity if not for the work of Karen Frank and others who were involved in the early conservation efforts. Frank researched and preserved the history of the hollow and its unearthly tales.

Over the past 130 years, there have been at least four deaths in the hollow. In 1874, some local boys discovered a dead man hanging from a tree. His death was classified as a murder, and he was never identified. No one was ever charged with the crime. It may have been a case of vigilante justice. Other rumors said it was the Ku Klux Klan, though that is unlikely because the Klan primarily operated in the South during that time. Over the years,

the ghost of the dead man has supposedly appeared many times near the spot of his execution. It is reported that when the moon is out, one can hear a ghostly child or baby crying for the dead man.

Death came again to the hollow in 1881. Three armed men robbed Robert McClure's general store in McKeesport and fled into the hollow to hide. McClure and about twenty other angry men armed themselves and tracked the robbers. When they confronted the thieves in the hollow, McClure was shot and killed. The criminals managed to escape. It was not until seven years later that Ward McConkey was convicted and executed for the murder, though he maintained his innocence. There are those who believe that McClure's ghost haunts the hollow, the site of his untimely demise.

It wasn't long until another death was associated with the area. Edward Woods drowned in the river in 1887, shortly after he had crossed on the ferry. His death was believed to be an accident, but rumors abounded about questionable circumstances. When his hat was found near the entrance of the hollow and away from the scene of the accident, it only fueled the suspicions. He makes ghost number three.

There was one fatality in the Bowman Brick plant in 1905. Mike Sacco, an employee, was crushed between an elevator and the third floor of the factory. His ghost may haunt the hollow as well. Another unconfirmed murder involves two bank robbers from Clairton. They had decided to use the hollow as a meeting place to divide up the cash. When they got there, one of the robbers became greedy and killed his partner. Some versions of the story say that the money remained hidden and was never found, the real hiding place being known only by the dead robber.

In addition to ghosts, Dead Man's Hollow was once said to be home to a much scarier creature. A newspaper from 1893 supposedly contained a report of a giant snake that was between thirty and forty feet in length. Its gigantic head was two to three feet in diameter. The man who reported the snake to the paper claimed that he was so shocked that he passed out. (Most suspect that the stills in the hollow had something to do with the incident.) There are no reports of the snake harming anyone, and it has not been seen again.

Another interesting stop on the Youghiogheny River Trail is Dravo Cemetery. It is located in Elizabeth Township, Allegheny County, not very far from Dead Man's Hollow. The cemetery, which contains more than seven hundred grave sites, is located by the railroad tracks behind the former site of Dravo Methodist Church. The small church, originally

constructed in 1824, burned in 1920 and was not rebuilt. The Elizabeth Township Historical Society now maintains the property. Graves in the cemetery date back to the early 1800s, and veterans from both the War of 1812 and the Civil War are buried there. Over the years there have been many stories about strange noises among the tombstones. It is said to be guarded by a spectral two-headed dog that chases trespassers to the edge of the cemetery. The property is also visited by a ghost train that is often heard but only occasionally seen. Over a century ago, there was a train wreck near the cemetery that killed several people. Now its crew is destined to repeat its final run again and again.

The Real Story of the "Most Haunted House in America"

The story of the house at 1129 Ridge Avenue on Pittsburgh's North Side has everything that you would want in a spooky tale. According to the story, the house was constructed for Charles Wright Congelier, a carpetbagger who returned north to the Pittsburgh area in 1870. He brought with him his Mexican wife, Lyda, and a servant girl named Essie. Everything was going well for the Congeliers for the first year that they were in the house. Things quickly fell apart, however, when Lyda discovered that her husband was having an affair with Essie. She stabbed her husband to death when she caught them in bed. Lyda then cut off Essie's head. Friends found her sitting on the porch, cradling Essie's head, which was wrapped in a blanket. Lyda was taken away and institutionalized.

For twenty years, the house went unoccupied, until it was remodeled in 1892 to house railroad workers. It was only used for two years. Those staying in the house kept hearing ghostly sobbing and screams.

In 1900, a doctor named Adolph Brunrichter purchased the property. Brunrichter seemed to keep to himself and was rarely seen. In August, a loud scream came from inside the house. When the neighbors gathered outside, trying to figure out what was going on, they heard an explosion and saw a bright red flash bounce around the inside of the house. Every window in the house shattered and the ground shook. The sidewalk near the house even cracked. When the police arrived and entered the house, Brunrichter was nowhere to be found. What they did find was gruesome. Upstairs, they found the decomposing body of a woman tied to a bed. Her head had been cut off. In the basement, they found five

more bodies buried in shallow graves, all without their heads. When they found Brunrichter's journal, they realized that he was trying to find ways to keep severed heads alive. He claimed to have been successful for short periods of time.

The house again sat empty until the Equitable Gas Company purchased it to house workers. Four immigrant workers were staying in the house when the next incident occurred. One day, when they were eating dinner, one man got up to get something from the kitchen. After a few minutes he didn't come back, so his brother went to check on him. The other two men soon heard a scream and charged into the kitchen to find the cellar door open. When they went into the basement they discovered that one man was impaled with a board and the other was hanging from the rafters above him. Both were dead. The other two men felt something brush past them on the stairs, and all of the doors in the house slammed shut at once.

About 1905, electricity and strange lights began to arc between rooms inside the house. Sometimes it would even arc out into the street. The house had not been wired for electricity at that point and was still using natural gas, which made the phenomena even more unusual. The electrical activity eventually slowed down and was last witnessed in 1919. On November 14, 1927, the house was destroyed when the large Equitable Gas storage tank two blocks away exploded. The explosion killed dozens of people and damaged hundreds of buildings. The only structure that they could find absolutely no trace of was 1129 Ridge Avenue. Only a deep crater occupied the space that used to be the building's foundation.

In September, just before the tank exploded, Dr. Brunrichter resurfaced in New York. He became known as the "Pittsburgh Spook Man," and his story was told in a newspaper there. He spoke of the murders, orgies and demonic possession. After being held for a month in New York, he was released because the authorities could not verify his identity and they thought he was mentally ill. He vanished and was never seen again. On the wall of his cell, he wrote in blood, "What Satan hath wrought, let men beware."

One can see why it was called the most haunted house in America.

But there is one problem. Despite being a great ghost story, the details are almost entirely fabricated. No written version of the story has been found before the book *Haunted Houses* by Richard Winer and Nancy Osborn, written in the 1970s. There were Congeliers who lived at 1129 Ridge Avenue, but according to the Pittsburgh City Directories, the earliest they were in the house was 1921 or '22. The family remained in the house into

An 1890 plat map showing the location of the natural gas tanks on Pittsburgh's North Side. Ridge Avenue was one block north of the tanks. *Courtesy of the Library and Archives Division, Senator John Heinz Pittsburgh Regional History Center.*

the 1950s. The directories spell the name a little differently every time—Canglier, Cangellere, Cangelere, Cangeliere and even Cancelliere. This may have made it more difficult to track the origin of the story over the years. As far as the mad Dr. Brunrichter, he never existed. At least half a dozen serious researchers have attempted to identify him in the past ten years, and all have come up empty-handed.

One element of the story that is true is that Equitable Gas did have several large gas tanks nearby, called gasometers. A leak had been discovered in the largest tank, and on the morning of November 14, 1927, a repair crew was sent to fix it. For some reason, the repairmen used an open-flame acetylene torch. At 8:43 a.m., the five million cubic feet of natural gas inside the tank exploded. The blast ignited two other nearby tanks, which also exploded. For twenty miles, buildings shook and glass shattered. The fireball traveled straight up in the air, higher than nearby Mount Washington. Pieces of metal launched hundreds of

A photo of the large gasometer that exploded on November 14, 1927. The blast killed 28 people and injured over 450. *Courtesy of the Library and Archives Division, Senator John Heinz Pittsburgh Regional History Center.*

feet. Water mains and sewer lines were ruptured. The neighborhood around the blast was heavily damaged. A total of 28 people were killed and over 450 were injured. According to newspaper reports, one of those who died was Mary (or Marie) Congelier. She had been hit and severely cut with a piece of flying glass. She bled to death on the way to the hospital. Contrary to the story, the house only suffered damage from flying debris and was torn down years later during the construction of the Route 65/I-279 interchange.

While most of the details of the story are false, it still functions as a community memory of the tragedy in 1927. The name of one of the victims is still tied to the event through the story. When Winer and Osborn first heard the tale in the 1970s, enough time had passed for the details to become confused. What was clear was that the traumatic impact of the explosion still resonated in the community.

The Haunted Museum

The Senator John Heinz Pittsburgh Regional History Center documents, preserves and interprets the heritage of western Pennsylvania. As one of the ten largest history museums in the country and a Smithsonian affiliate, the History Center is home to thousands of artifacts and millions of documents and images that tell the story of the region. The museum building itself is a historic structure, once a massive warehouse for the Chautauqua Lake Ice Company. Like any good historic building, it has an interesting story behind it, and a few ghosts.

The building that stands today on Smallman Street, formerly called Pike Street, was completed in 1899. It was used by the ice company for many years before it was sold to Adelmann Lumber Company in 1950. The icehouse was nearly identical in construction to the one that stood on the site before it, which had also been owned by the ice company and was the site of destruction and tragedy.

Before electric-powered refrigeration, ice was sold to businesses and individuals to preserve food. The Chautauqua Lake Ice Company cut ice from Lake Chautauqua in New York and shipped it to Pittsburgh in insulated railroad cars. The cars could pull directly into the icehouse building, where the ice could be unloaded and stored. To keep the ice cold, the building had very thick walls, few doors and few windows. The windows that it did have were small and covered with iron shutters. No

An early sketch of the Chautauqua Lake Ice Company building. Later in the twentieth century, the building became the Heinz History Center. *Courtesy of the Library and Archives Division, Senator John Heinz Pittsburgh Regional History Center.*

staircases existed above the second floor. The upper levels could only be reached by elevator. The ice was distributed around the city in horse-drawn carts.

On February 9, 1898, a fire broke out at the icehouse. The cause has never been determined. When firemen arrived, the fire was small and there was not much smoke. But there was a problem. The elevators had stopped working. There was no way to get to the fire from the inside. On the outside, there were only the few small windows, some of which were blocked. The firemen could not stop the fire from spreading. Part of the building was being rented by the Union Storage Company and it had eight hundred barrels of whiskey inside. The ice company also stored tanks of compressed ammonia, used for an ice-making process. When the fire reached the barrels and tanks, things started to explode.

The first blast caused the six-story wall in the back of the building to collapse onto Mulberry Way and the houses that lined it. Neighboring buildings caught fire. Several firefighters were buried under the rubble, and

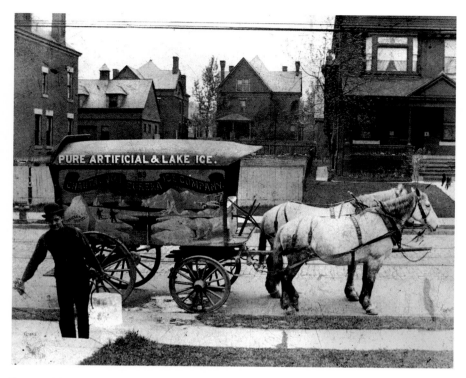

Ice was delivered in horse-drawn wagons by the Chautauqua Lake Ice Company. *Courtesy of the Library and Archives Division, Senator John Heinz Pittsburgh Regional History Center.*

one man was decapitated. More explosions followed as one barrel after another ignited. The large wooden beams that supported the structure were thrown hundreds of feet. By the time the fire was extinguished, eighteen were dead and dozens were injured. Two of the deceased were the sons of the owner, William Scott. Scott reconstructed the building and finished by 1899, but the disaster was not soon forgotten.

Decades later, the building became the home of the Historical Society of Western Pennsylvania, and it was remodeled into the museum that it is today. It wasn't very long before some members of the staff noticed some unusual visitors. Strange noises were heard in storage areas on the fifth floor, including the sound of ice being chipped and cracked. At least one former staff member thought he had heard someone walking, only to discover that no one was there. Another employee, working late, caught a glimpse of a figure at the top of the stairs between the first and second floors. When she turned toward the stairs, the figure was gone.

Other strange noises and voices were heard on the old loading dock and on the fourth floor by operations personnel.

A former security guard had a more direct encounter. While watching a security monitor one night, he spotted a man in a broad-rimmed hat sitting on a couch near the restrooms on the first floor. Thinking that a patron had stayed after closing and become confused or lost, he went to investigate. The guard found no one. When he returned to the security station, he saw a dark shadow in the shape of the "hat man." It moved down the wall and disappeared into the floor.

Is the History Center haunted by the ghosts of those who perished in the tragic fire in 1898? Are the ghosts somehow connected to the thousands of artifacts in the museum? With so much history concentrated in one place, it is hard to say. Maybe if you visit the History Center, you will find out.

Ghosts on Campus

Duquesne University has long been a fixture on the "bluff" overlooking downtown Pittsburgh. Since 1878, it has educated students as a pillar of western Pennsylvania's academic community. Like any well-established and storied institution, Duquesne has a few ghost stories. The most interesting has been circulating for almost the entire life of the university. The origins of the story predate the university itself and relate to an old hospital that once occupied the site of "Old Main," the administration building.

Sometime in the mid-1850s, Doctor Albert G. Walter built a two-story hospital on the bluff, then known as Boyd's Hill. Walter was born in Germany in 1811. Orphaned at a young age, he managed to raise enough money to go to medical school at the University of Koenigsberg. After graduation, he spent time studying under some of the best surgeons in Berlin. Walter was ahead of his time, advocating medical and surgical procedures that later became standard practice. In Pittsburgh, he often clashed with quacks who sold patent medicines and even other physicians who did not understand his techniques. Only after his death would he be recognized for his work.

Dr. Walter was also an abolitionist. According to decades of oral tradition, Walter used his hospital to hide runaway slaves as a stop on the Underground Railroad. During that time, many escaped slaves were brought north through Pittsburgh on their way to Canada. Walter's hospital

was one of many safe locations in the area for slaves to hide. The ghost story emerges from that tradition.

There are actually two pieces of the story, both tied to the hospital. One account tells of an escaped slave who arrived in the middle of the night. He was dressed in rags, had been severely beaten and still had part of his shackles attached to his arm and to an iron collar around his neck. By the time he reached the hospital's doorstep, he was near death. Dr. Walter did his best to save him, but within a few hours the man died.

A few years later, the Civil War had begun, and wounded soldiers and prisoners were being shipped to Northern hospitals to recover. At least one but probably several severely wounded Confederate prisoners were said to have been sent to Walter's hospital. Despite Dr. Walter's best efforts, he was not able to save all of them.

Dr. Walter continued to operate the hospital until he passed away in 1876. He had contracted pneumonia after a visit to a patient in bad weather. In 1882, the Holy Ghost Fathers were looking for a suitable location for their new college to take permanent root. Pittsburgh Catholic College (later Duquesne University) had been operating out of rented space above a bakery on Wylie Avenue. When the opportunity came, they purchased the old hospital on top of the bluff and used the site to construct Old Main. The Holy Ghost Fathers had also purchased the lot directly across the street. Instead of demolishing the old hospital, they moved it across to the lot and added another story. The expanded building was first known as Saint John's Hall and later became Saint Mary's Hall. It was used for student housing.

According to tradition, both locations were haunted. The majority of the stories center on Saint Mary's Hall, however. On stormy nights, on the bottom floors of Old Main, it is said that the ghost of the escaped slave can be heard fighting the ghost of a dead soldier. The same battle could be heard in the basement of Saint Mary's as well. According to a story in *Duquesne Magazine* in 1940, if the slave won there was no trouble, but if the Confederate won there would be misery and woe. Just exactly how the victor was determined is unclear. The story was so well known that it became part of a freshman initiation ritual in the early twentieth century. The freshmen would be marched into the basement to hear the battle. If they did hear it, they were members of the select few who could attend the university.

Initiation ritual aside, many strange events were reported at the hall over the years. Noises were heard, chains rattled and footsteps walked

Saint Mary's Hall, originally Dr. Walter's hospital, served as student housing on Duquesne University's campus in the 1930s. *Courtesy of the University Archives and Special Collections, Duquesne University.*

up and down the steps when no one was there. A story that was handed down from the early days of the building involves a direct conflict with a ghost. When it was Saint John's Hall, it was home to some of the brothers and priests. One night, the ghosts were making so much noise that the men had had enough and went down to the first floor. They determined that the noise was coming from the basement. A big, unnamed German priest volunteered to go down after it. He yelled down the steps, "I'm coming to drive you out." The ghost answered him, saying, "Come ahead, I know all about you. You don't scare me." That response just

Old Main and Saint Mary's Hall in 1971. Saint Mary's was torn down a year later because it was structurally unsound. *Courtesy of the University Archives and Special Collections, Duquesne University.*

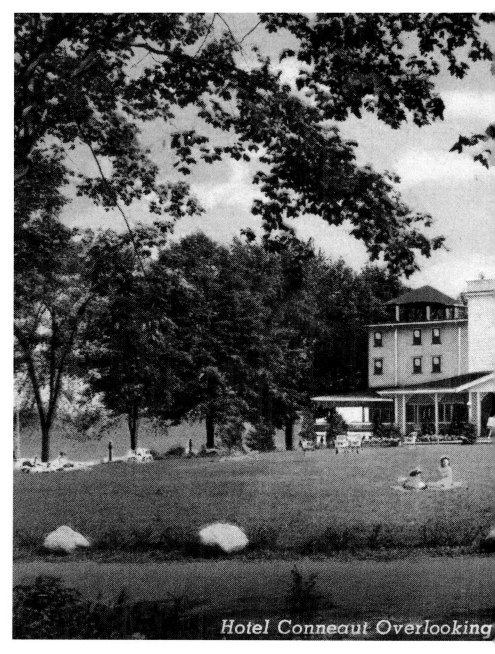

A postcard of Hotel Conneaut from the early 1900s. The hotel was known as the Crown Jewel of Conneaut Lake. *Courtesy of the Library and Archives Division, Senator John Heinz Pittsburgh Regional History Center.*

ke, Conneaut Lake Park, Pa.

5B-H1212

made the German priest angry, and he charged down and grappled with the ghost, hurling the specter to the floor. Holy water in hand, he dowsed the ghost and it vanished. The disturbances lessened after that.

While physically wrestling with a ghost seems like a tall tale, that story and the others serve several purposes. The tales recall the early and significant use of the site and building before it was part of the university. They also serve as a source of tradition and camaraderie among students who participated in the initiations in the basement. The German priest wrestling with and banishing the ghost can be seen as representing the triumph of faith in God over adversity. The Holy Ghost Fathers (the Spiritans) faced and overcame many challenges in establishing the university and throughout the early years. Their faith was reflected in every aspect of the school, even its ghost stories.

Saint Mary's Hall was used for many purposes over the years. By the early 1970s, the building was in bad shape and needed either substantial and expensive repairs or to be demolished. It was razed in 1972. With the old hospital gone, parts of the ghost story became associated with Old Main.

Haunted Hotel Conneaut

Located on Conneaut Lake in Crawford County, the Hotel Conneaut is a living link to the past. It is the only remaining hotel in Conneaut Lake Park, constructed in 1903 from a wing of the Exposition Hotel that occupied the site before it. The wooden hotel maintains the traditional, simple way of life that its guests enjoyed early in the century. There are no televisions or telephones. The only air conditioning comes from ceiling fans and the breeze off the lake. It is the perfect place for a ghost.

The hotel originally had 150 rooms, but the success of the park led to the addition of 150 more rooms and the Crystal Ballroom in 1925. That made it the largest resort in Pennsylvania at the time. Nicknamed "the Crown Jewel" of Conneaut Lake, the hotel once had a one-thousand-person dining room, a radio room, a bakery, a barbershop (where Perry Como once cut hair), a billiard room, a nursery and a taproom. It was in operation only in the summer, as it is today, to serve the tourists who came to the lake and the park.

Everything was going well at the hotel until April 29, 1943. During a thunderstorm, lightning struck the roof and started a fire. The fire destroyed

part of the roof, the dining room, the main lobby and 150 guest rooms. Since it was in the middle of World War II and certain supplies were being used in the war effort, the hotel could not obtain permission to repair the roof and interior of the damaged areas. Instead, the hotel was remodeled to accommodate the remaining 150 rooms.

According to legend, the fire also left the hotel with one permanent guest. The story says that a young bride and groom were staying at the hotel when the fire occurred. The groom was a soldier on leave from the war and took the opportunity to marry his true love, Elizabeth. When the fire started, the groom was in another part of the hotel. He went outside, thinking that Elizabeth would do the same. The bride didn't leave but instead searched through the smoke for her new husband. By the time he realized that she had not come out it was too late.

Over the years, many strange things have happened in the hotel. Whispers have been heard in the rooms, windows and doors open and close without explanation and water runs by itself. Some staff and guests have reported feeling a presence, especially on the third floor. A few claim to have been physically touched by a ghost; others smell perfume when no one is around. Guests have heard a knocking at their door only to find no one there when they open it. Sometimes ghosts have been seen, including Elizabeth in her white dress, a little girl on a tricycle and a couple dancing in the ballroom.

The interesting thing about this ghost story is that despite the decades of mysterious activity witnessed by dozens of staff and guests, the story of Elizabeth dying in the fire turns out not to be true. There were no guests in the hotel at the time of the lightning strike. So if the ghost bride is made up, what is going on at the hotel? The story of Elizabeth is a reminder of the fire, but are there other ghosts that are not part of the traditional legend? Maybe some guests had such a good time that they never want to go home.

Unique Places

Interesting Places, Strange Geography

The stories in this final section are about unique places and/or geographical features. All of these places have legends associated with them, and those legends run the gamut from murder to miracles. Location is an important and sometimes primary element in many types of folklore. This chapter collects legends about unique places that don't quite fit in the other parts of this book. They are tied to crime scenes, strange geographical and geological features and holy sites.

Murder Swamp

Murder Swamp is located just outside of New Castle, near the town of West Pittsburgh, in Lawrence County. Its name is self-explanatory. In the early part of the twentieth century, it was rumored that the mob would use the swamp to dispose of bodies because of its remote location. It was not necessarily surprising to find in the area the remains of someone who had crossed paths with the wrong person. A completely different kind of killer was also using the swamp to dispose of bodies from the 1920s to the early 1940s. It is believed by many crime historians that a series of dismembered and decapitated bodies found in the swamp was the work of a serial killer called the Mad Butcher of Kingsbury Run, also known as the Cleveland Torso Killer.

The Mad Butcher, who was never caught, claimed at least twelve victims in the Cleveland area from 1935 to 1938, although the exact body count is unknown. Most of his victims were transients who were living in shantytowns

or riding the rails during the Great Depression. Several of his victims were discovered in the Kingsbury Run area. The killer did not fit what we now call the usual profile of a serial killer because he (or she) chose victims from both sexes. The victims' heads were usually severed and often all that was found were pieces of their torsos. The case had the Cleveland Police Department baffled. Even the city's public safety director, the famous Elliot Ness, was unable to solve the crimes.

One determined police detective, Peter Merylo, decided to look outside of Cleveland for more clues. Merylo believed that the killer was riding the rails and carrying out his grisly mutilations in abandoned boxcars. He soon learned about some bodies that were discovered in Murder Swamp and became convinced that they were related to his case. At least three bodies had been discovered in the swamp in 1925, and all of them had been dead for different lengths of time. The victims, two males and one female, all had their heads severed.

The first body was discovered by a man named Samuel Hares on October 6, while he was looking for a place to hunt ducks and other game. As he was exploring the swamp, he noticed what appeared to be a human leg sticking out from under a log. He immediately went to nearby West Pittsburgh to alert the authorities. County Detective J.M. Dunlap and County Coroner J.P. Caldwell went back to the scene with Hares. It took them nearly an hour to find the location again. The spot was two miles from the nearest road. When they got back to the body, they discovered that it was a partially decomposed young man wearing no clothes. He had been decapitated, and the head was not found for several days. It had been buried under the other end of the log. The rest of the body had been covered with earth and leaves, but the leaves had not entirely wilted. That led the police to suspect that the body had been hidden recently. There were no local missing persons, and they could not identify the victim or the motive.

On Saturday, October 17, a pair of young hunters found a second headless body while on their way to look at the scene of the first. They found a partially clothed skeleton buried under some bushes, wearing a blue shirt and tan dress shoes. The authorities were again called to the scene. The police noted that the feet pointed north, as had the previous victim's. They were unable to find the man's skull. While volunteers looked for the second man's skull, which was ultimately found about two hundred yards away, a third skull was found. The third victim may have actually been the first, as it appeared to have been in the swamp

for close to a year. The third skull belonged to a female. Her body was never found.

The terrain at Kingsbury Run in Cleveland was very similar to that of Murder Swamp. Detective Merylo believed that the killer had claimed his first victims in the New Castle area. He spent some time riding the rails from New Castle to Cleveland undercover, but he was never able to catch the killer. Another male body was discovered in the swamp in October 1934. It was not decapitated but was found without clothing. Police speculated that the killing may have actually been a mob hit and may have been unrelated to the previous killings.

Merylo's railroad hunch may have been proved correct after a gruesome discovery in July 1936. Some railroad men at the New Castle Junction looked inside an old Pittsburgh & Lake Erie Railroad boxcar that hadn't been moved in five years. To their horror, they discovered a badly decomposed headless body. Under it were newspapers from Pittsburgh and Cleveland from July 1933. The cars were only three-quarters of a mile from the swamp.

After the murders finally stopped in Cleveland, another decapitated body was discovered in Murder Swamp. In October 1939, a man's body was discovered next to some month-old Youngstown, Ohio newspapers. It was also headless. The head was found in another empty Pittsburgh & Lake Erie railroad car, about seven hundred feet away. A year later, a gruesome discovery was made inside of three old boxcars that had been sent to Mckees Rocks (just outside the city of Pittsburgh) to be demolished. Inside each of the cars were the dismembered corpses of two unidentified men and one woman. They had been dead for several months. One of the victims had the word "Nazi" with an inverted z carved into his chest. After investigating, Merylo discovered that the cars had been sent from Youngstown. It seemed that the killer was working in a third location, and his reign of terror was not over.

A headless corpse was also discovered near Pittsburgh in 1939. It had been deposited in a dump along the Monongahela River. In the spring of 1941, two human legs were discovered in the nearby Ohio River. The following year, another headless corpse was discovered in the Monongahela River. By 1945, more mutilated bodies were discovered in other states in the Great Lakes region, such as New York and Michigan. Although these victims from outside of Cleveland were never officially added to the killer's total, many people, including Detective Merylo, believed that they were the work of the same man. The killer returned to Cleveland to claim what appears to be his final victim in 1950. His identity and motives remain a mystery to this day.

Around Murder Swamp, local legends say that the ghosts of the victims of the Torso Killer wander the swamp where they met their untimely demise. Some have even suggested that the deranged spirit of the Torso Killer still wanders his old hunting grounds, searching for victims.

The Lost Islands of Pittsburgh

The geography of Pittsburgh's "Point" and the merger of the Monongahela and the Allegheny Rivers into the Ohio River are the city's defining physical features. Many would be surprised to learn that the land and riverbanks around the Point looked much different in the colonial era and through most of the 1800s. Only during and after the Civil War were there any real attempts to maintain river depths and the shoreline. Before that, the features around the Point were constantly shifting. To the south of the Point in the Monongahela River there was a very long sandbar in the late 1700s. In the summer and fall, the Monongahela could become very shallow in parts. (General Braddock's army walked across it.) A 1795 map of the city even indicates that buckwheat was grown on the temporary island. To the north, two islands stood between the Point and the area now known as the North Shore.

When early settlers and explorers sailed down the Allegheny River toward the Ohio, they found two heavily forested islands that sat about seventy yards from shore and about forty-five yards apart. There is some debate over the actual size of the islands. Some early sources give the size of the western island, which extended partially into the Ohio River, as four hundred acres. An 1806 land transaction gave the size of the island as twenty acres. Yet another source states that the island was one-fourth of a mile long and one hundred yards across. The eastern island was described as slightly smaller than the western one. The size of both islands probably changed frequently as a result of river depth and currents that would either deposit material or cause erosion.

When the British forces came to western Pennsylvania to try to capture Fort Duquesne in 1755, the Delaware and Shawnee Indians gathered on the western island. After the Battle of the Monongahela, they returned there with prisoners. The Indians allegedly tortured and burned some of the captive soldiers. Their screams of anguish could be heard by French soldiers across the river at Fort Duquesne. At some point, a legend was spread that the islands and the nearby land (Allegheny West today) were known to the tribes

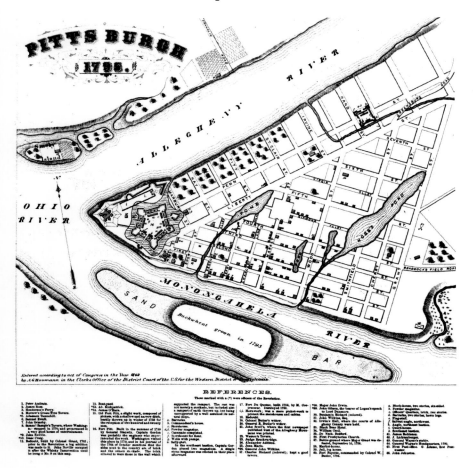

PITTSBURGH 1795.

ALLEGHENY RIVER

OHIO RIVER

MONONGAHELA RIVER

SAND BAR

Buckwheat grown in 1795

Entered according to act of Congress in the Year 1860 by A.G. Haumann in the Clerks Office of the District Court of the U.S. for the Western District of Pennsylvania.

REFERENCES.

A 1795 map of Pittsburgh showing Smoky Island and a sandbar in the Monongahela River. *Courtesy of the Library and Archives Division, Senator John Heinz Pittsburgh Regional History Center.*

as the Dark Place. The Indians never established a permanent settlement there because it was viewed as an evil place, inhabited by the ghosts of their enemies. Of course, the origin of the legend cannot be traced and therefore cannot be verified. Even if the story circulated during the colonial era, it may reflect more of the settlers' fears than those of the Indians.

The western island was occasionally used as a staging area for raids on Fort Pitt (especially during Pontiac's Rebellion) and surrounding settlements by hostile tribes. By the early 1780s, the island was a campsite of friendly Delaware tribes. It became known as Smokey Island because of the campfire and tobacco smoke that could be seen drifting into the sky. The eastern

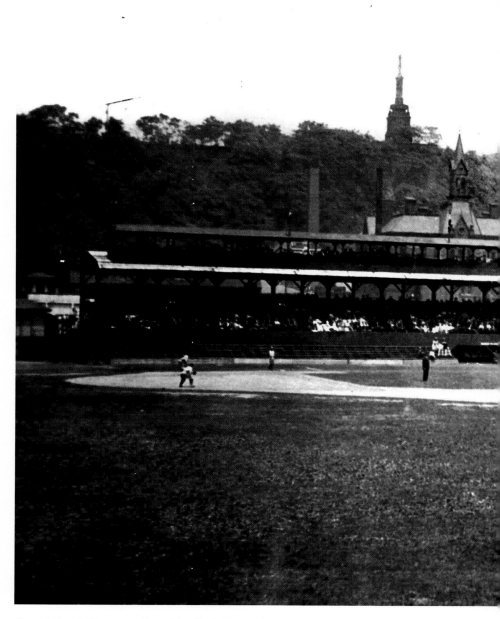

An early baseball game at Exposition Park. The park was located on land that used to be part of Killbuck Island. *Courtesy of the Library and Archives Division, Senator John Heinz Pittsburgh Regional History Center.*

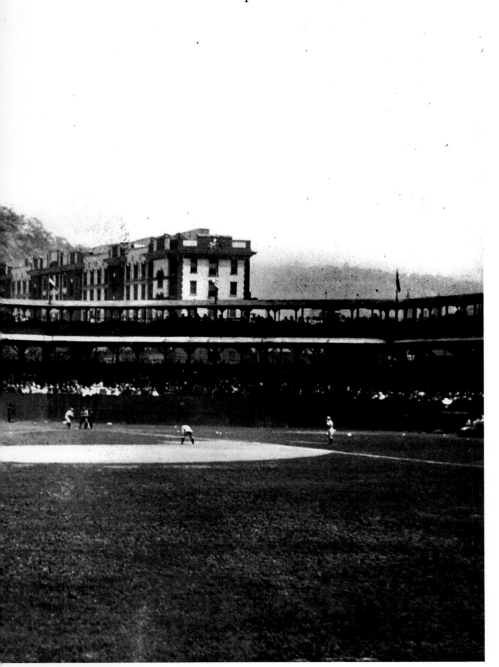

island became known as Nelson's Island, named after its early occupant, Ezra G. Nelson. Both islands appear on the Pittsburgh map of 1795.

Smokey Island soon received another name when it was given to Chief Killbuck of the Delawares as a belated reward for his assistance during the Revolutionary War. The chief would not have peace on Killbuck Island— he was soon harassed by Scots-Irish immigrants who forced him to flee. He eventually sold the island to Abner Barker in 1802 for $200. Soon, disputes arose because Chief Killbuck did not have the official documents that granted title to the island. Allegheny City (now Pittsburgh's North Side) eventually took control of the island while its future was being decided in the courts.

More significant than the changes in ownership were the environmental changes to the island. In the early nineteenth century, most of the trees were cut down and the land was leveled. By 1825, the two original islands had split into three. The short-lived center island was known as Low Island. An 1830 map again shows only the two original islands. A flood in 1832 washed away large portions of both islands. In the years that followed, residents of Allegheny City began filling in the channel that separated the island from the shore with earth from various construction projects. By 1850, Nelson Island was completely absorbed into the mainland, and Smokey/Killbuck Island was partially connected. Recently discovered river survey maps from 1859 show a greatly enlarged Killbuck Island, still partially connected. Another unnamed island appears that was about 480 feet in front of the Point in the Ohio River. The water level appeared to be very low at the time. Within a few years, the unnamed island disappeared, and what was left of Killbuck Island had completely merged with the north bank.

During the industrial era, the land that was Killbuck Island was used to hold expositions to showcase new technology and manufactured goods. In 1875, several large buildings were constructed to house the grand displays, amusements and concerts. A fire destroyed the complex in 1883. At the beginning of the century, the land served as the site for Exposition Park, the early home of the Pittsburgh Baseball Club. The Pirates played Boston in the first World Series in 1903 at Exposition Park, which was used by the team until 1909, when it moved to Forbes Field. The Pittsburgh and Western Railroad company utilized the area throughout the middle part of the century until the construction of Three Rivers Stadium. Today, Heinz Field, PNC Park and the Carnegie Science Center are located on the site of Pittsburgh's lost islands.

The Underground River

If you are from western Pennsylvania or have been around the area for a while, chances are you may have heard stories about Pittsburgh's fourth river. The mysterious river is located underground, below the city and the other rivers. For many, it brings to mind images of dark, water-filled subterranean passageways in the vein of a Jules Verne novel. It was once even blamed for the disappearance of the Lost Bomber of the Monongahela. Someone suggested that the plane had slipped down into the underground river and was carried away. So is there really an underground river running beneath western Pennsylvania?

Yes and no. The underground "river" is not a true river like the Allegheny or Ohio. It is actually a very large sand and gravel aquifer created during the last ice age. Its official name is the Wisconsin Glacial Flow. The aquifer flows under the Allegheny and Ohio Rivers and in some areas is as much as one mile wide and thirty-five feet deep. It is like a tunnel that is filled with rocks and sand. The water slowly flows through this material at a rate of about five miles a day. The sides and the bottom of the tunnel are made of rock, and the top is a layer of clay that separates it from the other rivers above. This aquifer differs from others because it follows a channel, and in that sense it is like a river. It begins to the north of Warren County and roughly follows the path of the Allegheny River to the Ohio. In Beaver County, the water emerges from the aquifer and enters the Ohio River.

Though it can't be seen, the river has been utilized for over a century as a source of water. The Harmony Society in Economy, Beaver County, was the first group to use the aquifer's waters. In 1873, society members drilled a well to access the clean water. By the 1890s, several buildings in downtown Pittsburgh had drilled wells into the aquifer. It served as an alternative to the polluted river water on the surface. In the following years, many other buildings and companies would also access the underground river, including PPG Place, Duquesne Light and West View Water. The most visible use of the aquifer is the fountain at the Point.

If you find the explanation of the underground river mundane, don't worry. There are a handful of New Age believers who think the river has a higher purpose. They have linked the four rivers to Mayan Indian prophecies and the idea that there will be an earth-changing spiritual event when the current Mayan calendar ends on December 21, 2012. According to their interpretation, Pittsburgh's Point, the meeting place of the four rivers, will

serve as one of twelve sacred portals and "points of light." The water in the underground river will develop healing powers before that happens, and it will attract people from all around the world. The group believes that the Maya originated in this region before moving south to Mexico because the oldest archaeological site in North America is Meadowcroft Rockshelter (sixteen thousand years old) in Washington County. (For the record, archaeologists reject that idea of Mayan origins.) The tradition of the four rivers was carried with them as they traveled south.

Relics and Miracles of Saint Anthony's Chapel

If someone wanted to find the world's largest collection of relics of the saints, he would go to Rome of course. The Vatican houses the world's largest collection of Christian relics. If one could not make it to Rome, where else could he find a large collection of relics? Another European city? The Holy Land? No, in fact, one would not have to go very far at all. To find the world's second-largest collection of saintly relics, one would have to go no farther than the Troy Hill neighborhood of Pittsburgh. Saint Anthony's Chapel, located on Harpster Street, houses close to five thousand relics in over eight hundred reliquaries. The chapel is part of the Most Holy Name of Jesus Parish of the Roman Catholic Diocese of Pittsburgh and has been a place of pilgrimage and healing for over a century.

One might reasonably wonder just how so many relics ended up in a chapel in western Pennsylvania. The story of Saint Anthony's Chapel and its relics is intertwined with the life of Father Suitbert Goedfried Mollinger, pastor of Most Holy Name of Jesus Parish from 1868 to 1892. Mollinger was born in the Netherlands in 1828, the sixth of eight children. His devout mother raised Father Mollinger and his siblings as Roman Catholics even though their father was a Protestant. Young Mollinger studied medicine in Naples, Rome and Genoa before deciding to enter the seminary in Ghent. He later moved to the United States to complete his studies and be ordained. After serving as a pastor in the Diocese of Erie, Mollinger asked to transfer to the Diocese of Pittsburgh, which had a large and growing population of Catholics. He served at Saint Mary's in Mckees Rocks and St. Alphonsus in Wexford and helped establish the mission that would become St. Teresa's in Perrysville before being transferred to Most Holy Name in 1868.

Unique Places

By the time Father Mollinger arrived in Troy Hill, he had already amassed a substantial collection of relics. The use of relics has a long tradition in the Catholic Church, dating back to the earliest days of Christianity. Relics are meant to serve as reminders of the holiness of the saints. There are three different classes of relics. A first-class relic is actually the body or part of the body of a saint. A second-class relic is a possession owned or used by the saint. A third-class relic is an object that has come into contact with a first-class relic.

Father Mollinger began collecting relics to protect them from the turmoil that was occurring in Europe. The Papal States were eliminated with the unification of Italy, and a new wave of anti-Catholicism swept across parts of Europe and especially Germany. Mollinger used his family's fortune to travel to Europe to track down and purchase relics that had been removed or stolen from churches and monasteries. He brought them back to the United States to keep them safe. For the rest of his life, he continued to bring relics to Troy Hill.

After a relic-hunting trip in 1880, Father Mollinger proposed that a new, larger church be built that would have enough room to house his collection of relics. Unfortunately, the parish did not have enough money for such a large undertaking. Since he could not construct a new church, Father Mollinger decided to personally finance the building of a chapel to house the relics. Mollinger always had a special devotion to Saint Anthony, so he decided to name the chapel after him. On the Feast of Saint Anthony on June 13, 1882, the cornerstone was laid in place. The Romanesque-style chapel was quickly completed, and it was dedicated exactly one year later. Several years later, it was expanded to add life-sized Stations of the Cross.

After Mollinger's death in 1892, his successors continued to acquire relics. Since the opening, thousands of visitors have come to see the collection. Some of the most significant relics housed in the chapel include the skeleton of Saint Demetrius that is under the tabernacle altar and the skulls of Saint Macharius, Saint Theodore, Saint Stephana and the martyrs who died with Saint Ursula. One reliquary contains a piece of the True Cross surrounded by relics of Saint John the Baptist, Saint Mary Magdalene, Saint Blasé, Saint Stephen, Saint Lawrence, Saint Dionysus, Saint Anthony of Padua, Saint Agnus, Saint Nicholas, Saint Sebastian, Saint Justina, Saint Barbara, Saint Lambert, Saint Catherine and Saint Cecilia. The chapel houses other pieces of the True Cross, as well as relics from many other saints like Saint George and Saint Mauritius.

St. Anthony's Chapel
and Parish,
Troy Hill, Pittsburgh, Pa.

A postcard of Saint Anthony's Chapel in Troy Hill, Pittsburgh, from the early 1900s. *Courtesy of the Library and Archives Division, Senator John Heinz Pittsburgh Regional History Center.*

The chapel has always been a place of healing. In the early years, so many sick and physically challenged people used to visit that the streetcar that ran nearby was nicknamed "the ambulance." At one point, as many as fifteen thousand people were coming each day. Father Mollinger was known as a great healer and physician. The priest used his training to develop many unique remedies and cures that he prescribed to his parishioners. Many attributed his healing skills to his personal holiness, prayers and God's intervention. Of course, Father Mollinger was not the only reason that people came and continue to come to the chapel for healing. The sick hoped for the intercession of the saints whose relics are housed in the chapel. Many miracles and miraculous cures have been reported in association with the relics. The piles of crutches, canes and braces left at the chapel over the years are a testament to these occurrences. Some can still be seen in the museum across the street.

SELECTED BIBLIOGRAPHY

Archival Materials and Interviews

Blue Mist Road Interviews. Series of transcribed interviews conducted in North Park, Allegheny County, by Emily Jack. July and August 2004.

Bridge Book, USCG Cutter *Forsythia*, February 2–February 17, 1956. National Archives and Records Administration.

Charles M. Stotz Papers, MSS 21. Library and Archives Division, Senator John Heinz Pittsburgh Regional History Center.

Louis Darvarich Affidavit, July 19, 1934. http://gustavewhitehead.org.

Matuga, Jim. Phone interview with author, October 2005.

Report of Air Force Aircraft Accident, Aircraft 44-29125, January 31, 1956. National Archives and Records Administration.

Shablesky Family. Interview with Emily Jack about Ray Robinson, November 14, 2004.

Articles

Batz, Bob, Jr. "Green Man's Legend Continues to Glow." *Pittsburgh Post-Gazette*, October 31, 1998.

Bauder, Bob. "Charlie No Face: The Life and the Legend." *Beaver County Times*, March 10, 2007.

Bothwell, Margaret P. "Killbuck and Killbuck Island." *Western Pennsylvania Historical Magazine* 44, no. 4 (1961): 343–60.

Bowman, Lee. "Underground Railroad Left Ghost of Slave to Haunt Duquesne U." *Pittsburgh Press*, September 1978.

"B-25 Crashes in River Here; Two Missing, Four Rescued." *Pittsburgh Post Gazette*, February 1, 1956.

Carver, George. "Legend in Steel." *Western Pennsylvania Historical Magazine* 27, no. 3–4 (1944): 129–36.

Chmiel, Louis, and Nick Engler. "The Legend of No. 21." *WWI Aero Magazine* (August 2001).

Delear, Frank. "Gustave Whitehead and the First Flight Controversy." *Aviation History* (March 1996).

"Detective Finds Missing Head this Afternoon." *New Castle News*, October 8, 1925.

Domenick, Rose A. "Nature Preserve Full of Legend, Folklore Expanding with Help of Local Groups." *Pittsburgh Tribune-Review*, March 27, 2008.

Dudurich, Ann Saul. "Kecksburg UFO Debate Renewed." *Pittsburgh Tribune-Review*, August 3, 2003.

Ferrick-Roman, Karen. "First-Flight Fight—Who Was the First to Fly?" *Beaver County Times*, December 17, 2003.

"Find Headless Remains of Man in Railroad Car." *New Castle News*, July 3, 1936.

Fishwick, Marshall W. "Sons of Paul: Folklore or Fakelore?" *Western Folklore* 18, no. 4 (1959): 277–86.

Fuller, Jeff. "Local Group Investigates Blue Mist Phenomenon." *McKnight Journal*, October 27, 2005.

Gibb, Tom. "People in Kecksburg Want to Resolve What Fell from the Sky in 1965." *Pittsburgh Post-Gazette*, March 9, 2003.

Gigler, Rich. "Pittsburgh's Man of Steel." *Pittsburgh Press*, August 12, 1979.

Gilley, Jennifer, and Stephen Burnett. "Deconstructing and Reconstructing Pittsburgh's Man of Steel: Reading Joe Magarac against the Context of the 20th-Century Steel Industry." *Journal of American Folklore* 111, no. 442 (1998): 392–408.

Glover, Lynn. "Researchers Out for Sunken B-25 Bomber." *Pittsburgh Tribune-Review*, July 18, 1999.

Grinnell, David. "The Tank that Blew Up." *Western Pennsylvania History* (Summer 2008).

"Gruesome Discovery of Revolting Crime Is Made by Hunter." *New Castle News*, October 6, 1925.

"Gruesome Find Made by Group of Boys Friday." *New Castle News*, October 14, 1939.

Guzzo, Maria. "Thrice-Told Tales Haunt Storyteller." *Pittsburgh Tribune-Review*, October 29, 1995.

"King of the Keelboatmen Hauled Flour from Early Mill at Noblestown." *Pittsburgh Press*, January 14, 1934.

La Russa, Tony. "Stories of the Paranormal Haunt Region." *Pittsburgh Tribune-Review*, October 31, 2003.

Lowry, Patricia. "In Plane Sight." *Pittsburgh Post-Gazette*, July 8, 1999.

McGrath, John. "Duquesne Then and Now." *Duquesne Monthly* (March 1940).

Miller, Eric. "Once Known as the 'Dark Place,' Allegheny West Has a Haunting Past." *Observer*, October 23, 1996.

Millward, Robert, and Kathleen Millward. "Making History in the Wilderness: Christopher Gist's Explorations into Western Pennsylvania." *Western Pennsylvania History* (Summer 2008).

O'Donnell, John. "Missing B-25 Creates Web of Silence." *Valley News Dispatch*, June 29, 1979.

O'Neill, Brian. "Ghosts of Old Allegheny Still Walk the North Side." *Pittsburgh Press*, October 31, 1991.

Opatka, Kim. "Kecksburg Crash Controversy." *Latrobe Bulletin*, May 6, 1989.

Ove, Torsten. "Searchers Say They Can Find 'Ghost Bomber' in the Mon." *Pittsburgh Post-Gazette*, April 4, 1999.

"Police Hunt Ditched Airplane and Two Missing Men." *Pittsburgh Post-Gazette*, February 2, 1956

Randolph, Stella, and Harvey Phillips. "Did Whitehead Precede Wright in World's First Powered Flight?" *Popular Aviation* (January 1935).

Ravasio, Mary. "A Haunting Jaunt: Stories of Unexplained Sights and Sounds at Dead Man's Hollow and Dravo Cemetery Echo along the Youghiogheny River Trail." *Pittsburgh Post-Gazette South*, October 31, 2001.

Rodgers, Ann. "So How Did the Point Get on a Mayan Calendar?" *Pittsburgh Post-Gazette*, June 22, 2008.

Ruetter, Clifford J. "The Puzzle of a Pittsburgh Steeler: Joe Magarac's Ethnic Identity." *Western Pennsylvania Historical Magazine* 63, no. 1 (1980): 31–36.

Smith, Ryan. "Staff Have Ghostly Experiences at Hotel Conneaut." *Meadville Tribune*, October 15, 2006.

"State Police Detail Aiding in Search of Swamp this Afternoon." *New Castle News*, October 19, 1925.

"Submerged B-25 Still Eludes Hunt." *Pittsburgh Post-Gazette*, February 15, 1956.

"Swamp Reveals New Mystery as Body Is Found." *New Castle News*, October 16, 1934.

Swetnam, George. "An Account of Mike Fink." *Western Pennsylvania Historical Magazine* 66, no. 3 (1983): 304–05.

———. "Hospital of History." *Pittsburgh Press*, November 3, 1968.

———. "The Return of Mike Fink." *Pittsburgh Press*, June 10, 1962.

Templeton, David. "The Kecksburg Files." *Pittsburgh Post Gazette*, September 9, 1998.

———. "The Uninvited." *Pittsburgh Press*, May 19, 1991.

Thomas, Lillian. "Fire, Ice: A Chilling Tale." *Pittsburgh Post Gazette*, February 3, 2002.

Tinsley, M. Ferguson. "This Time, Zombie Land Tale Is True." *Pittsburgh Post-Gazette*, October 31, 2000.

"Twenty-Eight Die in Natural Gas Blast—Disastrous Explosion in North Side of Pittsburgh." *Plattsburg Sentinel*, November 15, 1927.

Valentine, Matt. "Pittsburgh's X-Files." *Pittsburgh Pulp*, October 30, 2003.

Wertz, Marjorie. "Experts Dismiss Idea that British Army Payroll Was Buried near Circleville." *Pittsburgh Tribune-Review*, May 11, 2007.

White, Thomas. "The Ghost Bomber of the Monongahela." *Mysteries Magazine* 1, no. 3 (2003): 48–52.

———. "Islands of the North Shore." *Bastion* (Autumn 2000).

Williams, Edward G. "Treasure Hunt in the Forest." *Western Pennsylvania Historical Magazine* 44, no. 4 (1961): 383–96.

Wilson, Sharon. "Mike Fink: Paul Bunyan of the Keelboatmen." *Western Pennsylvania Historical Magazine* 58, no. 4 (1975): 575–76.

Books

Anderson, Fred, ed. *George Washington Remembers: Reflections on the French and Indian War*. New York: Rowman & Littlefield Publishers, Inc., 2004.

Badal, James Jessen. *In the Wake of the Butcher: Cleveland's Torso Murders*. N.p.: Kent State University Press, 2001.

Baldwin, Leland D. *The Keelboat Age on Western Waters*. Pittsburgh: University of Pittsburgh Press, 1941.

Barkun, Michael. *A Culture of Conspiracy: Apocalyptic Visions in Contemporary America*. Berkeley: University of California Press, 2003.

Blair, Walter, and Franklin J. Meine, eds. *Half Horse Half Alligator: The Growth of the Mike Fink Legend*. 2nd edition. New York: Arno Press, 1977.

Brunvard, Jan Harold. *Be Afraid, Be Very Afraid: The Book of Scary Urban Legends*. New York: W.W. Norton and Company, 2004.

Cleland, Hugh. *George Washington in the Ohio Valley*. Pittsburgh: University of Pittsburgh Press, 1955.

Darlington, William, ed. *Christopher Gist's Journals with Historical, Geographical and Ethnological Notes*. Pittsburgh: J.R. Weldon & Co., 1893.

DeLeon, Clark. *Pennsylvania Curiosities: Quirky Characters, Roadside Oddities & Other Offbeat Stuff*. Guilford, CT: Globe Pequot Press, 2001.

Ellis, Bill. *Aliens, Ghosts and Cults: Legends We Live*. Jackson: University Press of Mississippi, 2001.

————. *Lucifer Ascending: The Occult in Folklore and Popular Culture*. Lexington: University Press of Kentucky, 2004.

Goldberg, Robert Alan. *Enemies Within: The Culture of Conspiracy in Modern America*. New Haven, CT: Yale University Press, 2001.

Hadley, S. Trevor. *Only in Pittsburgh*. Cincinnati: Educational Publishing Resources, 1994.

Knight, Peter. *Conspiracy Culture: From Kennedy to the X-Files*. London: Routledge, 2000.

Kopperman, Paul E. *Braddock at the Monongahela*. Pittsburgh: University of Pittsburgh Press, 2003.

Nesbitt, Mark, and Patty A. Wilson. *The Big Book of Pennsylvania Ghost Stories*. Mechanicsburg, PA: Stackpole Books, 2008.

Nickel, Steve. *Torso: The Story of Elliot Ness and the Search for a Psychopathic Killer*. Winston-Salem, NC: John F. Blair, Publisher, 1989.

Ohler, Samuel R. *PittsburGraphics: Graphic Studies in Paragraphs and Pictures Pertaining to Pittsburgh, Pennsylvania*. Pittsburgh: S.R. Ohler, 1983.

O'Meara, Walter. *Guns at the Forks*. 2nd edition. Pittsburgh: University of Pittsburgh Press, 2005.

Peebles, Curtis. *Watch the Skies: A Chronicle of the Flying Saucer Myth*. Washington, D.C.: Smithsonian Institution Press, 1994.

Rasmussen, William M.S., and Robert S. Tilton. *George Washington: The Man Behind the Myths*. Charlottesville: University Press of Virginia, 1999.

Ritenour, John S. *Old Tom Fossit: A True Narrative Concerning a Thrilling Epoch of Early Colonial Days*. N.p.: J.R. Wheldon Company, 1926.

Schorr, David, Gregory Jelinek and Louis Baysek, eds. *St. Anthony's Chapel in Most Holy Name of Jesus Parish*. Pittsburgh: J. Pohl Associates, 1997.

Swetnam, George. *Devils, Ghosts, and Witches: Occult Folklore of the Upper Ohio Valley*. Greensburg, PA: McDonald/Sward Publishing, 1988.

Trapani, Beth E. *Ghost Stories of Pittsburgh and Allegheny County*. Reading, PA: Exeter House Books, 1994.

Ward, Matthew C. *Breaking the Backcountry: The Seven Years War in Virginia and Pennsylvania 1754–1765*. Pittsburgh: University of Pittsburgh Press, 2002.

Young, Robert. "Old Solved Mysteries: The Kecksburg UFO Incident." In *The UFO Invasion*. Edited by Kendrick Frazier, Barry Karr and Joe Nickell. Amherst, NY: Prometheus Books, 1997.

ABOUT THE AUTHOR

Thomas White is the university archivist and curator of special collections in the Gumberg Library at Duquesne University. He is also an adjunct lecturer in Duquesne's History Department and an adjunct professor of history at La Roche College. White received a master's degree in public history from Duquesne University. Besides folklore and western Pennsylvania, his areas of interest include public history and American cultural history.

If you enjoyed this book, you may also enjoy Michael W. Sheetz's

Kill for Thrill

$19.99 • 128 pages • 40 images • ISBN 978-1-59629-498-1

During the winter of 1979, southwestern Pennsylvania was rocked by a series of sensational murders, sparking a thirty-year criminal justice saga. A week of brutal, seemingly random killings culminated in the provocation and fatal shooting of Patrolman Leonard Miller, an officer new to the town of Apollo's police force and only twenty-one years old. Little more than a year later, two men were convicted of the rash of homicides and sentenced to death—yet both are alive today. Incorporating details of the central characters' personal lives as well as the state's court system, criminologist Michael W. Sheetz here relays the awful story of the so-called "kill for thrill" crime spree with the drama of a novelist and the insight of an officer of the law.